POSTCARD HISTORY SERIES

Clarksville

IN VINTAGE POSTCARDS

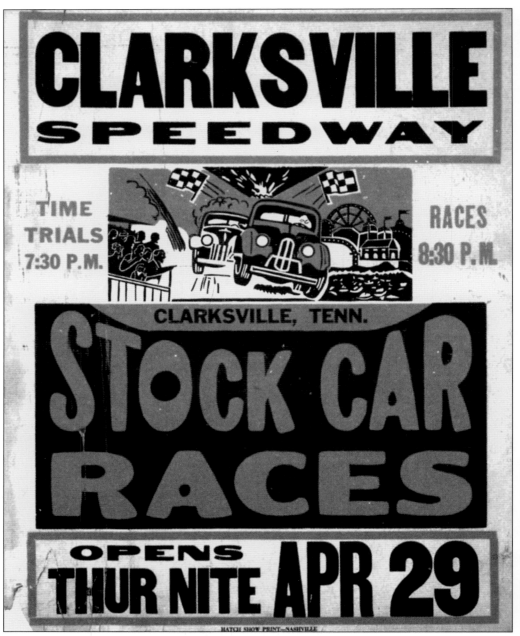

This is a postcard created from an old poster for Clarksville Speedway. Hatch Show Print in Nashville printed these in 2001.

POSTCARD HISTORY SERIES

Clarksville

IN VINTAGE POSTCARDS

Billyfrank Morrison

ARCADIA
PUBLISHING

Published by Arcadia Publishing
Charleston, South Carolina

Printed in the United States of America

Library of Congress Catalog Card Number: 2004105904

For all general information contact Arcadia Publishing at:
Telephone 843-853-2070
Fax 843-853-0044
E-mail sales@arcadiapublishing.com
For customer service and orders:
Toll-Free 1-888-313-2665

Visit us on the Internet at www.arcadiapublishing.com

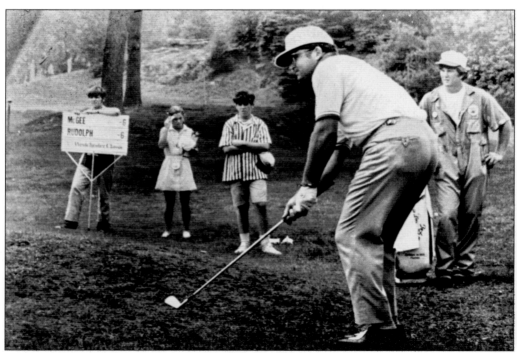

Clarksville native Mason Rudolph won six Professional Golf Association (PGA) events and was a member of both the Walker and Ryder Cup Teams.

CONTENTS

ACKNOWLEDGMENTS

I would be remiss in my obligations if I did not thank the collectors who have so graciously traded cards with me over the years. They include: Ridley Wills II, Franklin, Tennessee; Joe Woosley Sr., Hopkinsville, Kentucky; Mitch Kinder, Cleveland, Tennessee; and my brother, Pat Morrison, Jasper, Alabama.

I also wish to express my appreciation to Dr. Howard Winn, president of the Montgomery County Historical Society, for his generous advice during this effort, and to Eleanor Williams, Montgomery County historian, for providing considerable historical information and offering many corrections and suggestions for my manuscript. I am genuinely grateful and indebted to Shirley Kenney-Tomasi, executive director of the Arts and Heritage Development Council, for proofreading and influencing much of my material.

I give heartfelt thanks to my family and friends, too numerous to name, who have encouraged me and helped me locate cards over the years.

A very special thank you is offered to my lovely and loving wife, Evelyn, for her complete support in all my postcard endeavors. She patiently followed as I prowled antique shops, flea markets, card shows, and estate sales all over North America and Europe. And I thank her for sometimes embracing, sometimes ignoring the beautiful postcard mess I enjoy in my home office.

Last, but certainly not least, I would like to pay tribute to my father, Frank William Morrison Sr., for instilling in me an appreciation for "old things" and the value of preserving them. He was killed in a robbery attempt on February 24, 1979.

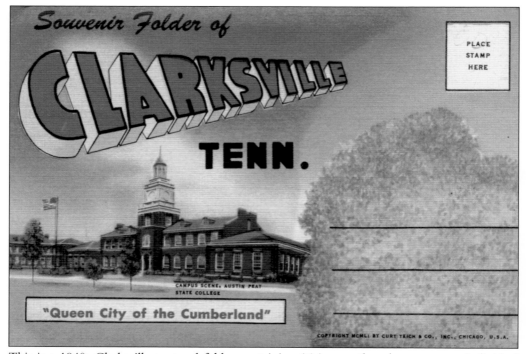

This is a 1940s Clarksville postcard folder containing 16 images that also appear on individual postcards. Folders almost always contain several paragraphs of narrative and 2 to 18 images. Most folders are approximately the size of a vintage postcard, 3.5 inches by 5.5 inches.

INTRODUCTION

Collecting Clarksville postcards started innocently enough some 30 years ago. While teaching high school, I used a group of old postcards as a visual aid. After they served their purpose, I decided to locate a building featured on one of the cards and discovered it was gone. That incident caused me to view postcards as links to Clarksville's past and to value them, not in monetary terms, but as ephemeral evidence of history that can never be replaced or replicated. Since then, I have made an avocation of collecting postcards. The search has taken me to faraway places and enriched my life.

Postcards reveal multitudes have moved across pages of Clarksville's past: the family of a future president; a postmaster general; a Supreme Court justice; two governors; movie stars; professional and Olympic athletes; the only three-time Pulitzer Prize winner; the first female basketball coach ever to be offered a major college men's program; renowned artists of every genre; the Screaming Eagles of the 101st Airborne on their way to rendezvous with destiny; and numerous other interesting personalities.

The cards also show that the city's experiences are as intriguing as its people. There were Indian attacks; fires, floods, and tornados; Night Riders burning barns during the Tobacco War; Ku Klux Klan organizing in a war-torn South; trains plummeting from a turn bridge into the Cumberland River, not once, but twice; a Grand Ole Opry star transforming a lake and cave into a resort; and the secretive Clarksville base playing a significant role in projects related to atomic weapons. Today, Clarksville's history continues, and hopefully the best is yet to come.

Clarksville is a very special city. It extends from the Kentucky border along the perimeter of Fort Campbell, south to the Cumberland River, and west beyond Interstate 24. Often still, I have to remind myself that it was the people of Clarksville (past and present) who created all that is shown or told about on the cards. The subjects of the cards make Clarksville different and interesting, and after traveling all over the world, I must say, "There ain't no place like it."

Throughout the years of collecting, my passion has remained similar to that found in a tent revival and the quest for cards continues. But even if it ended today, the pleasure gained from collecting and researching the cards has given me tremendous personal satisfaction.

This book will provide collectors, historians, and Clarksvillians an easy reference to many printed postcards. I have made the information as interesting as possible with a blend of documented Montgomery County history and information gleaned from personal interviews, letters, and the cards themselves. Hopefully, this book will whet the historical appetites of its readers and perhaps be the necessary antecedent for postcard collecting.

So, go ahead, take a postcard tour of Clarksville, Tennessee.

BIBLIOGRAPHY

PRIMARY SOURCES

Beach, Ursula S. and Eleanor Williams. *Nineteenth Century Heritage, Clarksville, Tennessee*. Oxford, MS: Guild Bindery Press, 1989.

Douglas, Byrd. *Steamboatin' on the Cumberland*. Nashville, TN: Tennessee Book Company, 1961.

Halliburton, John H. *Clarksville Architecture*. Nashville, TN: Parthenon Press, 1977.

Waters, Charles M. *Historic Clarksville: The Bicentennial Story, 1784-1984*. Clarksville, TN: Historic Clarksville Publishing, 1983.

West, Carroll Van. *The Tennessee Encyclopedia of History & Culture*. Nashville, TN: Rutledge Hill Press, 1998.

Williams, Eleanor S. *Homes and Happenings*. Oxford, MS: Guild Bindery Press, 1990.

Wills, Ridley. *Touring Tennessee*. Franklin, TN: Hillsboro Press, 1996.

NEWSPAPERS AND PERIODICALS

The Leaf-Chronicle
Cumberland Lore
The Corn Sheller

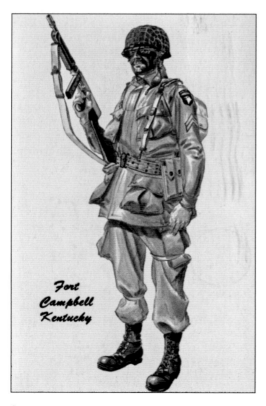

This postcard shows a drawing of a trooper of the 101st Airborn [*sic*] Division that parachuted into Normandy on D-Day, 1944.

One

EARLY AND RARE
POSTCARDS

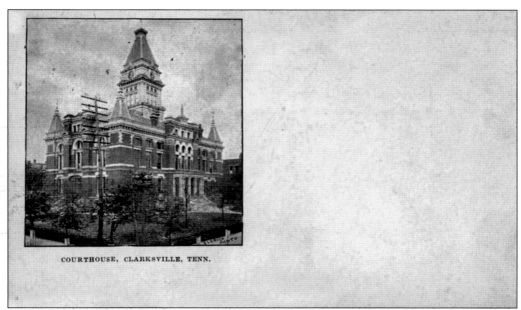

COURTHOUSE, CLARKSVILLE, TENN.

This view of the courthouse is featured on a rare private mailing card authorized by an act of Congress on May 19, 1898. The handwritten message reads, "Have seen your old manager Guy R. He is running the furnace of the Red River Iron Co. here. This is a pretty lively town." The card is signed "Bill." Country music stars The Kinleys used this building on the cover of their recent CD entitled *The Kinleys II.*

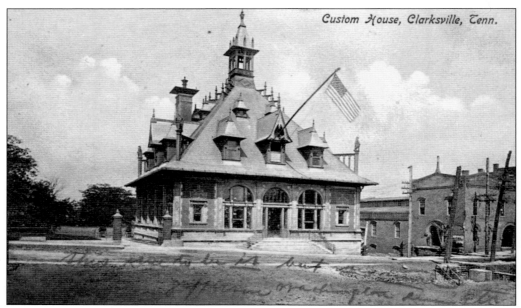

Custom House, Clarksville, Tenn.

This strikingly uncommon building served as the customs house and post office until the 1930s. It housed the Clarksville Department of Electricity from the 1930s until 1982. Today, it is the Customs House Museum and Cultural Center. This sepia card shows an open field across the street from the museum where *The Leaf-Chronicle* complex is today. It is reputed to be one of the most photographed buildings in the South.

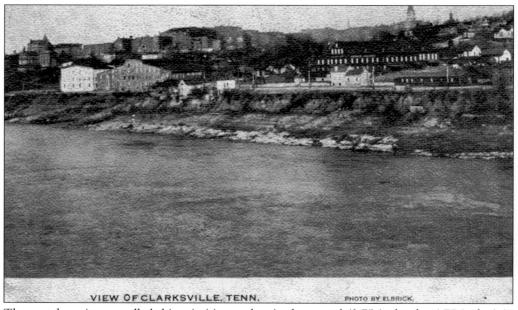

VIEW OF CLARKSVILLE, TENN. PHOTO BY ELBRICK.

The postal service cancelled this primitive under-sized postcard (3.75 inches by 4.75 inches) in 1903. Taken by Elbrick, this photo presents Clarksville from the south bank of the Cumberland River. These early postcards are a great representation of our history. This type of card is created using a printing press, ink, and engraving plates.

Clarksville twins Bill and Phil Harpel are Tom E. McReynolds's great-grandsons and were fourth-generation owners of this business. Furniture makers also made caskets, so it was practical for undertakers to sell both. In the early 1900s, Mr. McReynolds would send the embalmer by train to the home of the recently deceased, and the horse drawn hearse would be dispatched later.

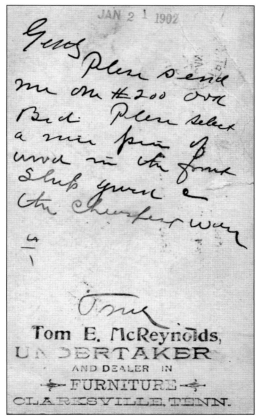

This postcard from a souvenir packet of 12 offers an early view of the city. While this appears to be an aerial view, it is a drawing created in Germany before the advent of airplanes. The accuracy of the detailed view can be challenged: there is a train crossing the Cumberland River and another traveling north along Front Street, and it is doubtful that there were sailboats on the Cumberland River during the 1800s.

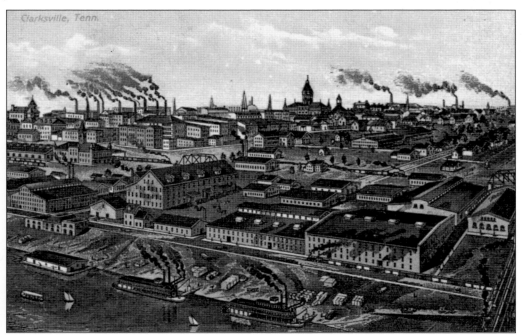

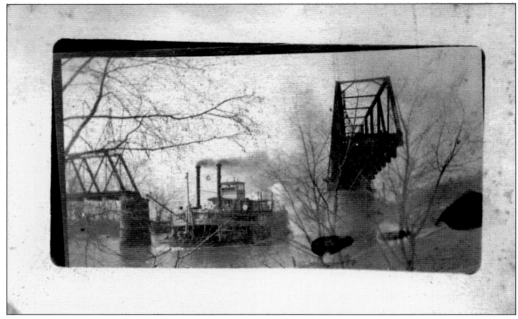

This primitive postcard of the Louisville and Nashville (L&N) turn bridge may pre-date 1900. The card was never mailed. It shows an old Cumberland River packet going downriver. The photographer would have been positioned approximately where Coldwell Baker Conroy Marable and Holleman Real Estate Inc. is located today. During the Civil War, Confederate troops fleeing Forts Defiance and Clark set fire to this bridge. Unfortunately, it did not burn and federal troops were able to use it.

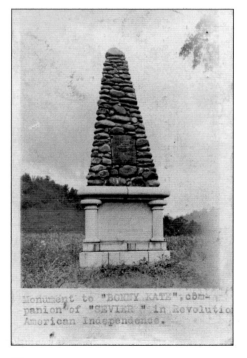

Monument to "BONNY KATE", companion of "SEVIER" in Revolution American Independence.

This Washington County monument honors Catherine Sherrill Sevier (1754–1836), the second wife of John Sevier and sister-in-law of Valentine Sevier (1746–1800). Valentine managed the initial toehold, albeit a tenuous one, on the Cumberland River at Clarksville. Indians killed 10 members of Valentine's family and scalped his 12-year-old daughter Rebecca. She survived.

This is likely the earliest postcard printed of Dunlop Mills. The mill shipped both barrels and sacks of flour, meal, and seed all over the South and to Europe. It is not known what the scaffold-like structure to the left of the chimney is. Destruction of these buildings began in 2002 and continues in 2004, demonstrating that being on the National Register of Historical Places does not ensure preservation.

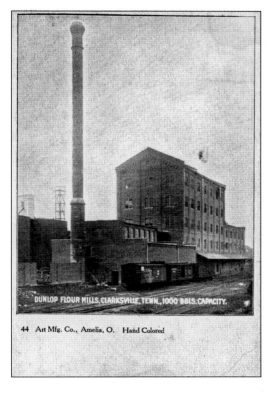

44 Art Mfg. Co., Amelia, O. Hand Colored

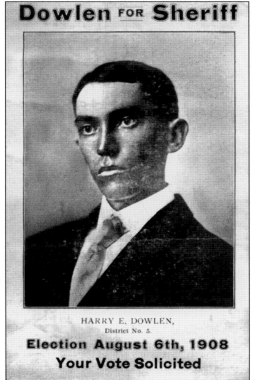

Harry E. Dowlen is pictured as a district five candidate for sheriff in the August 6, 1908 election. The card is postmarked Clarksville, July 15, 1908, but it is stamped Dogwood. It is addressed simply to Tom Ferrell.

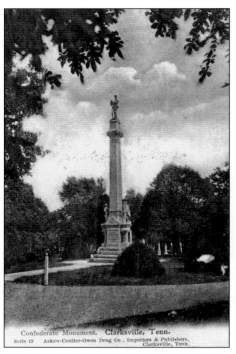

Confederate Monument. Clarksville, Tenn.
Serie 19 Askew-Coulter-Owen Drug Co., Importers & Publishers, Clarksville, Tenn.

This early black-and-white card features the monument in Greenwood Cemetery that was dedicated to the Confederate dead. Askew-Coulter-Owen Drug Company had this card printed in Germany. The card has an opening, similar to an envelope, enabling the correspondent to enclose a personal message. These soldiers' names should shine in the pages of Southern history books forever, but instead there are discussions by some about removing or destroying Confederate monuments. Eliza Jane Poitevant Nicholson, who wrote under the pen name Pearl Rivers, said it best when she formed the following verse:

> Tread lightly, 'tis a soldier's grave,
> A lonely, mossy mound;
> And yet to hearts like mine and thine
> It should be holy ground.

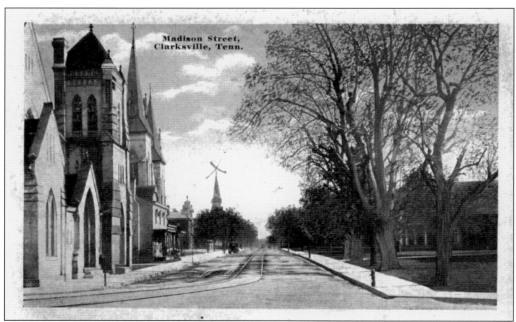

Madison Street, Clarksville, Tenn.

The photographer was standing at South Third when he took this photograph of Madison Street. The first building on the left is First Christian Church. The house on the right belonged to Micajah H. Clark, treasurer of the Confederacy, who entertained Jefferson Davis here on occasions. In this postcard postmarked 1920, the only noticeable difference between it and a 1911 photo are fire hydrants installed sometime after 1911.

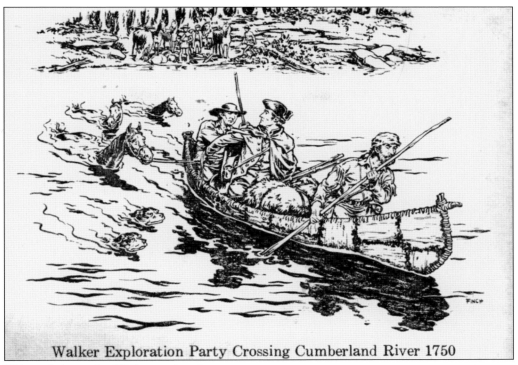

Walker Exploration Party Crossing Cumberland River 1750

This card shows the Walker exploration party crossing the Cumberland River in 1750. A typed message on the reverse states, "In 1742 Thomas Lee, Acting Governor of Virginia opened the gates to the settlement of Indian Territory by sending Dr. James Walker and John Lewis through the Cumberland Gap and canoeing down past the site that would one day be called, Clarksville. Goodbye Redman."

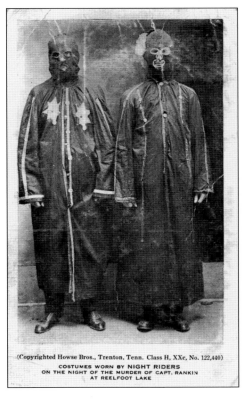

(Copyrighted Howse Bros., Trenton, Tenn. Class H, XXc, No. 122,440)

COSTUMES WORN BY NIGHT RIDERS
ON THE NIGHT OF THE MURDER OF CAPT. RANKIN
AT REELFOOT LAKE

Night Riders were also known as the Association, Possum Hunters, and Hillbillies. They led an agrarian revolt against the trust created by Buck Duke of North Carolina. In the early 1900s, Duke had an estate worth several hundred million dollars while Middle Tennessee and Western Kentucky farmers were offered the starvation price of 3¢ per pound for the best dark-fired tobacco in the world.

The Ku Klux Klan first appeared in Clarksville in 1868; the group met at Dunbar Cave and Stewart College. Their last known appearance in Clarksville was in the 1980s during a peaceful march that ended on the courthouse steps.

Clarksville, Tenn., Nov. 16, 1891.
Dear Sir:—I have the agency of the Nashville Daily Banner, and as my remuneration depends upon the number of copies sold, it is my desire to increase the number of subscribers in this place to the limit of possible readers of a daily paper, and to that end I shall deliver to you for one week free of charge, the Daily Banner, that you may judge of its merits and then subscribe for it if you desire. The paper will be delivered to you each morning by 6 o'clock, thereby reaching you considerably in advance of the other Nashville dailies. The subscription to the Banner is only 10 cents a week and I hope that after trying the paper for the time prescribed, you will become a regular subscriber.
Very respectfully, Walter Tomlinson.

Walter Tomlinson is soliciting Clarksvillians to subscribe to the *Nashville Daily Banner*. This 1891 postal card advertises subscriptions as 10¢ a week.

Two

TOBACCO AND OTHER COMMERCE

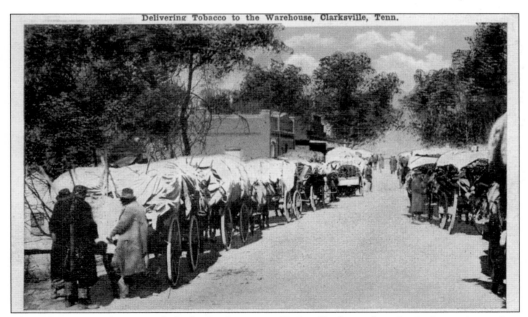

Delivering Tobacco to the Warehouse, Clarksville, Tenn.

These farmers are bringing dark-fired tobacco to Clarksville floors for sale during a time when Clarksville and tobacco were synonymous. There are other cards showing tobacco-laden wagons lined along the Cumberland River. These cards are postmarked from 1904 to 1923. Teams stayed at local livery stables overnight while drivers slept in the wagons with the tobacco.

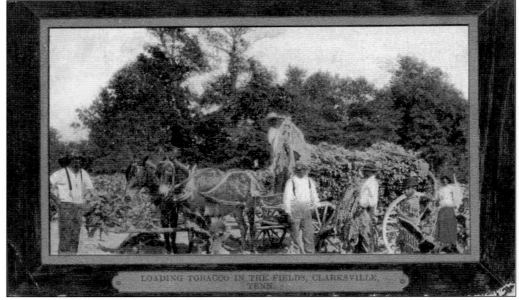

LOADING TOBACCO IN THE FIELDS, CLARKSVILLE, TENN.

Six African Americans load a wagon to be taken to market. Sharecroppers or field hands, black and white, cut and loaded the tobacco. Even today, tobacco is one of the most labor-intensive crops grown. Having put Clarksville on the map, tobacco was a phenomenon that ended, more or less, years ago. This image, as with many old postcards, can be found in both black-and-white and color.

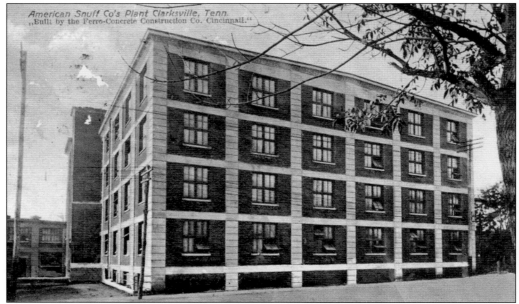

American Snuff Co's Plant Clarksville, Tenn. "Built by the Ferro-Concrete Construction Co. Cincinnati."

Dark leaf tobacco is well suited for snuff, and today, American Snuff Company is a leading producer of snuff. The water tower seen in other postcards of the factory was removed in October 2003. There is usually a pervasive olfactory sensation in the immediate area of the factory. Some who live east of the factory say it helps them forecast the weather.

The Petri Cigar Factory was located at Bradley and High Streets and was used as a hospital during the Civil War. It was destroyed in the tornado of 1999. The warehouse at 651 Bradley Street is now Queen City Motorcycle and Salvage, which is owned and operated by Billy Joe and Tandy Black. Tobacco presses and other equipment are still an integral part of the building.

Petri Brand Cigars - Rossi Brand Cigars Altamore Brand Cigars

PRICE LIST

EFFECTIVE OCTOBER 1, 1962

		Resale Price	List Price Per M	ORDER
WHOLE CIGARS:				
Petri Regulars	100s	3/30c	$75.00	
Europa	50s	1 / 10c	77.00	
HALVES CIGARS:				
Petri AA - 2's	100s	2/12c	48.00	
Sigaretto Kings	100s	5/30c	48.00	
Sigaretto Regular	100s	5/25c	40.00	
IL Capitano	100s	2/12c	48.00	
Squillo	100s	2/12c	48.00	
Vincitor 5 Pack	100s	5/25c	40.00	
Vincitor 2's	100s	2/10c	40.00	
Toscanelli	100s	5/25c	40.00	
La Gioia 5 Pack	140s	7/30c	Box 4.90	
Petri AA - 2's All occasion	50s	2/12c	48.00	
OTHER BRANDS:				
PETRI SMOKING TOBACCO:				
Spuntatura 14 ozs.		95c	.80c	
Ship To				

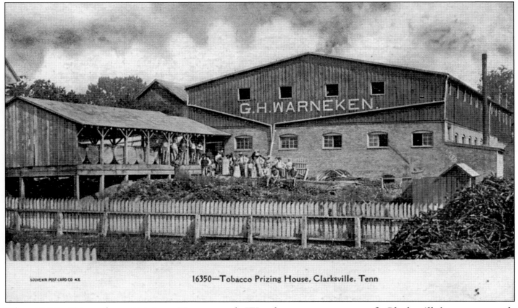

SOUVENIR POST CARD CO. N.Y. 16350—Tobacco Prizing House, Clarksville, Tenn

The G.H. Warneken Prizing House and Warehouse was one of Clarksville's many such establishments. There are postcards of the Grange, Elephant, and other warehouses. This warehouse was smaller than the Grange, which, with a capacity of 6,000 hogsheads, was reputed to be the largest in the world. Readers may recall that Huck Finn slept in a hogshead.

19

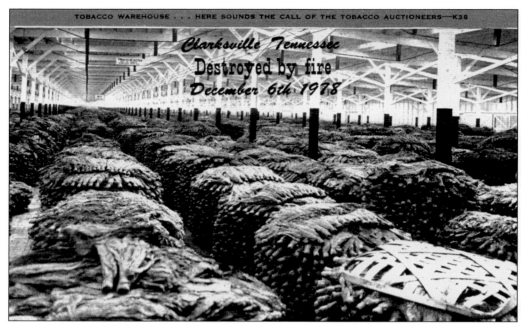

Printed information indicates this warehouse was destroyed by fire on December 6, 1978. There are two variations of this card, one with and one without information about the fire. Facts listed on the back include that some warehouses cover six-and-a-half acres under a single roof and three million pounds of tobacco are sold at a single auction. This is believed to be the Grange Warehouse.

LOOSE LEAF MARKET REPORT

CLARKSVILLE, TENNESSEE

TOBACCO MARKET WEEK ENDING ___JAN 22 1947___

Sales for week ___1.825.322___ Average ___27 3/4___

Sales for season ___2.454.598___ Average ___27 1/2___

Sales last season ___3.769.776___ Average ___30 63___

Pool receipts ___420.982___ lbs. included

J. FRED SMITH, Secretary

Clarksville Tobacco Board of Trade.

This Clarksville Loose Leaf Market Report shows sales information for the week ending January 22, 1947. It is addressed to E.J. O'Brien & Co. of Louisville, Kentucky.

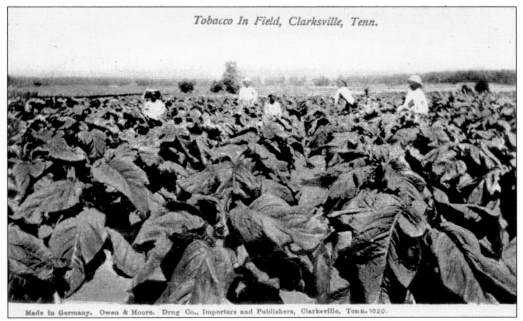

Tobacco In Field, Clarksville, Tenn.

Made in Germany. Owen & Moore. Drug Co., Importers and Publishers, Clarksville, Tenn. 1020.

A number of African-American field hands stand between rows of dark-fired tobacco. This color postcard was printed in Germany at the request of Owen and Moore Drug Company, Importers and Publishers. There are similar cards showing white field hands among rows of tobacco.

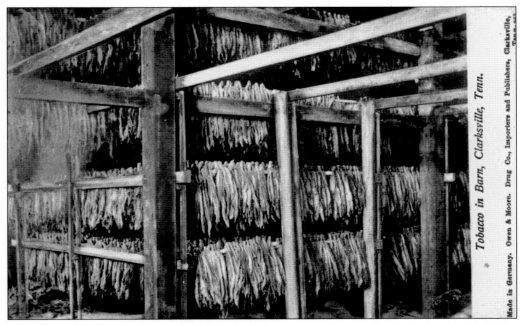

Tobacco in Barn, Clarksville, Tenn.

Made in Germany. Owen & Moore. Drug Co., Importers and Publishers, Clarksville, Tenn. 1021.

Clarksville's economy was centered on its dark-fired tobacco base before and after the Civil War years. In 1887, there were 20,000 hogsheads shipped out of Clarksville. During that period, dark leaf tobacco was known as "Clarksville Tobacco" in the European markets. This card shows tobacco in the barn. The back of this card is printed off center.

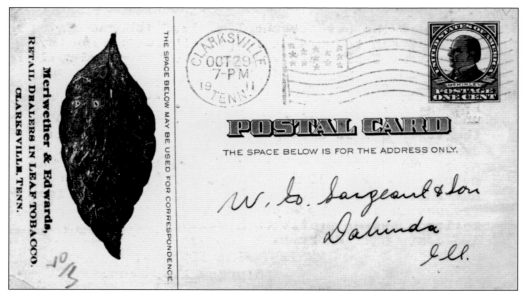

Retailers Meriwether and Edwards used this postcard as an advertisement. Postmarked 1911, the typed message on the reverse states, "Under the new revenue law, tobacco can be sold at retail without paying Government Tax." It goes on to say, "It's a crackerjack seller because it is cheap and good." These retailers had a warehouse located at 227 West Avenue.

This is an advertisement card printed by W.D. and C.N. Meriwether for Banner Tobacco Warehouse. A previous owner of this card used the back of it for a shopping list. Items included, "bones 19 lbs at 2 cts, lard 6 lbs at 8 cts, and tobacco, 25 lbs."

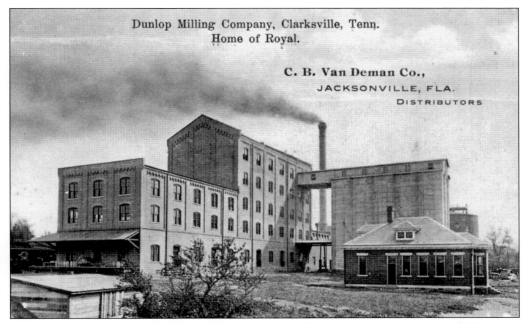

Dunlop Milling Company, Clarksville, Tenn.
Home of Royal.

C. B. Van Deman Co.,
JACKSONVILLE, FLA.
DISTRIBUTORS

Dunlop Milling Company was located at the east end of Franklin Street near the L&N Railroad. John T. Rabbeth of Hopkinsville, Kentucky, and Joseph P. Dunlop of Clarksville founded the business in 1893. The 80-foot-tall smokestack was visible from almost anywhere in Clarksville and often served as a landmark. What makes this card unusual is the stamp by "C.B. Van Deman Co., Jacksonville, Fla. Distributors."

The enterprising livery of S.A. Caldwell and John R. Shelton once stood on North Third Street between Main and Franklin Streets. It was built in 1895 for boarding horses. The proprietors also maintained buggies for hire.

Owen and Moore Building, Clarksville, Tenn.

The Owen and Moore Building was constructed in 1890 at Franklin and South Second Streets and was home to a drug store, bookstore, and music store. Around 1900, former employee Lauren B. Askew became a partner. Over the years, the building was home to McNeal and Edwards Ladies Clothing Store, McClelland Department Store, Bellamy Auction Company, and a civic center. There is also an older postcard variation of this building.

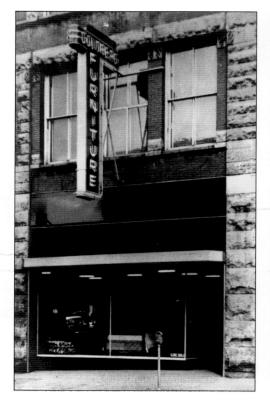

This card was sent to Mrs. A.J. Mayfield at 115 Munford Avenue to announce Goldberg Furniture's first anniversary sale from March 12 to March 20, 1948. Joseph Goldberg owned the furniture store, located at 215 Franklin Street. The Lillian Theatre, named for his daughter, was at Franklin and First Streets.

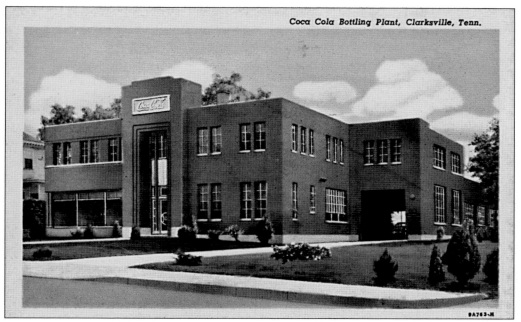

The Coca-Cola plant still stands at 330 North Second Street and still displays the "Coke" logo above the door. Today, it is home to Rubel, Halliburton, and Northington Insurance. Betty Morris writes on this 1949 card, "I went to the show last night with a boy named James Tipton and I am going swimming with him one day this week."

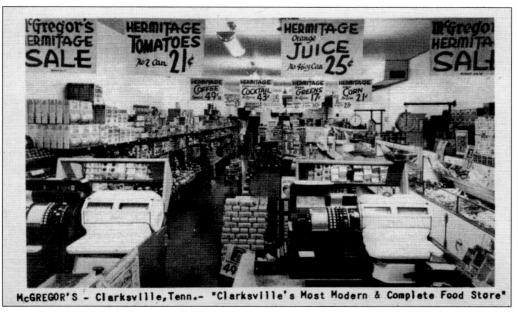

McGREGOR'S - Clarksville,Tenn.- "Clarksville's Most Modern & Complete Food Store"

Located at 126 Ninth Street and Main Street, McGregor's Grocery was "Clarksville's Most Modern Food Store." It was owned and operated by Paul M. McGregor, who served as mayor of Clarksville from 1953 to 1958. Note the costs of groceries in the early 1950s.

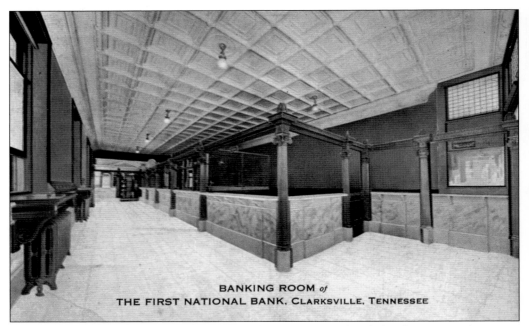

BANKING ROOM *of*
THE FIRST NATIONAL BANK, CLARKSVILLE, TENNESSEE

First National Bank was organized in 1865 as the Unionist Bank. Clarksvillians remember, years later, an armored truck delivering cash to the bank across from Joy's Jewelry two days before each Fort Campbell payday. The fort would then dispatch Jeeps, with 50-caliber machine guns mounted on them, to pick up the payroll. They also posted foot soldiers with M-1s on the street.

SOUTHSIDE BANK, Southside, Tenn. *Feb - 28 - 1923*

Batson + Andrews

Cunningham

We credit your account this day foreign items subject to payment.

DATE OR NUMBER	NAME	TOTAL CREDIT
28 inst. Total your cash letter		$30 15
	We enter for collection	

In 1908, the directors of the Southside Bank arranged for considerable renovations to the Southside School. On February 28, 1923, this card was postmarked at the Southside Post Office and mailed to Batson and Andrews of Cunningham, crediting their Southside Bank account with $30.15.

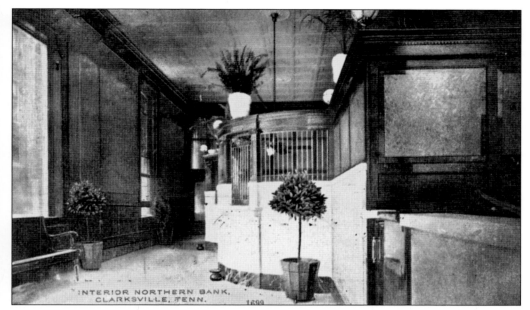

Founded on the public square in 1854 as Kennedy and Glenn's Bank, this bank became Northern Bank—named "Northern" because of its location in the state. During the Civil War, bank funds were smuggled to England for safekeeping and returned at the war's end. This building at 136 South Second and Franklin Streets was razed after the 1999 tornado. Interior views of banks were considered a security issue.

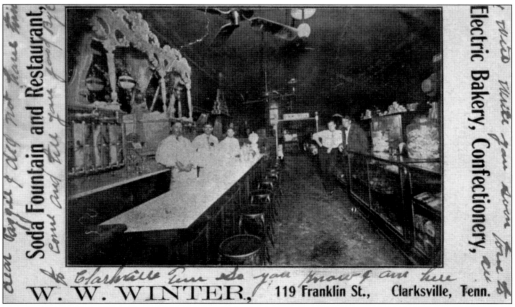

In 1907, William W. and Ella Winter owned the "Electric Bakery, Confectionery, Soda Fountain and Restaurant" at 119 Franklin Street. In 1911, their residence was listed as 119 1/2 Franklin Street, suggesting they lived in a portion of the building or perhaps behind it. This location is the former office of Judge Ray Grimes and today is the law office of Larry J. Wallace.

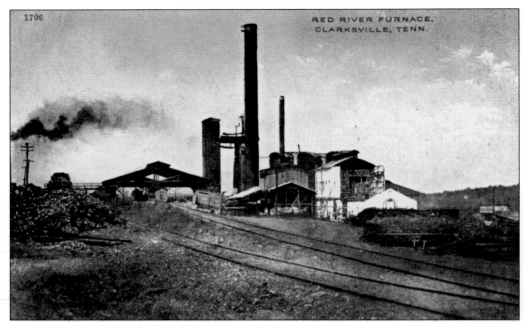

In 1890, Frank P. Gracey founded Red River Iron Furnace in the vicinity of Frosty Morn Street. It was a blast furnace and an important site for production of pig iron. It was also known as the Gracey/Woodward Furnace. There are at least two other postcard views of the furnace.

May 8, 1970

WOOL

HAVE TAKEN LARGE ORDERS FOR WOOL. WE NEED LARGE QUANTITIES OF WOOL TO FILL OUR ORDERS.

ALWAYS PAYING TOP MARKET PRICES. WILL BE YOUR ADVANTAGE GET OUR ATTRACTIVE PRICES WHEN YOU ARE READY TO SELL YOUR WOOL. CALL COLLECT.

LUI HEIMANSOHN
CLARKSVILLE, TENN.—50 FRANKLIN ST.

Day Phone 645-5851 Night Phone 645-6123

Lui Heimansohn once operated a flourishing business on the town square. The Heimansohn family bought old car batteries, cans, and animal hides (coon, fox, etc.), which were often stacked on the sidewalk in front of the building. In 1984, the business moved to its present-day location on the bypass. Curtis Mize married Jeannette Heimansohn and manages the successful scrap metal business.

LANGFORD WELDING
2012 KRAFT STREET
CLARKSVILLE, TENNESSEE 37040

J.T. Langford started Langford's Welding in Dover in 1938. In 1942, the business was located at 807 College Street. In 1970, the business moved to its current location on Kraft Street, where it thrives under the management of Tom Langford, Carolyn Butts, and other direct descendants of the Langfords. Tyler Butts, great-grandson of Mr. Langford, created this card.

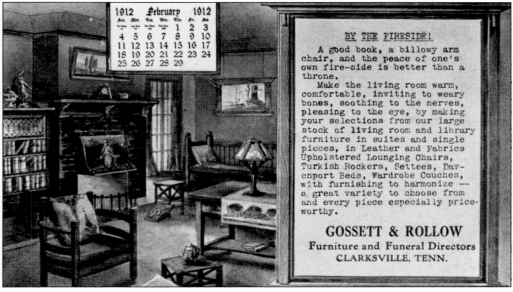

Charles A. Gossett, 817 College Street, and Arch B. Rollow, 323 South Third Street, owned and operated Gossett and Rollow Furniture and Funeral Directors. In 1911, the business was located at 109 Franklin Street and, according to city directories, had moved to 125 Franklin Street by 1917.

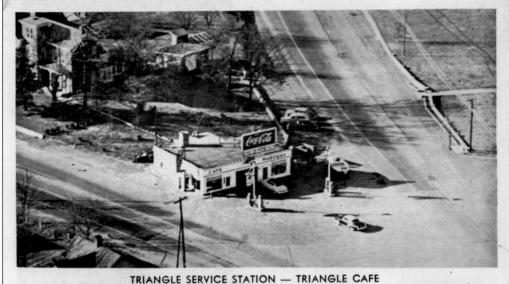

TRIANGLE SERVICE STATION — TRIANGLE CAFE
Mobilgas and Mobiloil — 24 Hour Service — Plate Lunches, Short Orders and Home Made Pies
Intersection of U.S. Hwys. 79 and 41A — Clarksville, Tennessee

The Triangle Service Station and Café provided Mobilgas, plate lunches, Coca-Cola, and homemade pies. The large home to the left was the Whitefield residence. Alex Trice, a tobacconist, built this home for his daughter shortly after the Civil War. The home had its own water tower, English gardens, wine cellar, and separate quarters for servants. Alex Darnell often visited family here as a child. The home was razed in the 1990s.

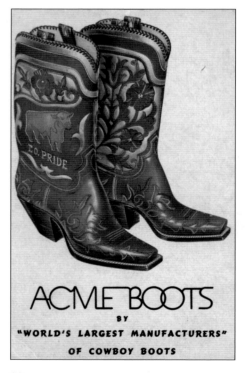

Acme Boot operations began in 1935 on Crossland Avenue in what became known as the "Mole-hole." The plant expanded to other locations and had spokespersons such as Joe Willie Namath, Joe Montana, O.J. Simpson, and Johnny Cash. Many Clarksville residents were Acme Boot employees, including Nell Myers, Linda Zimmerman, Bernice Peacher, Lynda Steelman, and Evelyn Teeple. Arsonists burned the Crossland Avenue building in 2003.

30

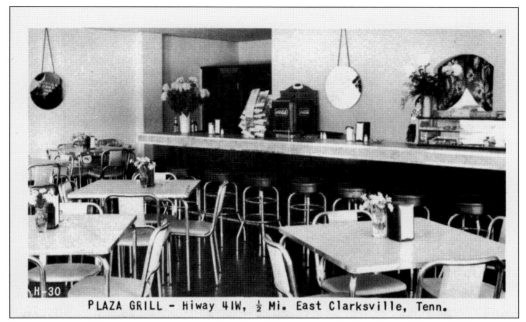

PLAZA GRILL - Hiway 41W, ½ Mi. East Clarksville, Tenn.

The Plaza was a wonderful, warm little restaurant that opened on Madison Street in the late 1940s. Under the management of Martha Cogburn and her husband, Ralph, locals were pampered and the eatery thrived. Danny Thomas often ate there and was provided seating with his name on it. It is now the Cumberland Grille.

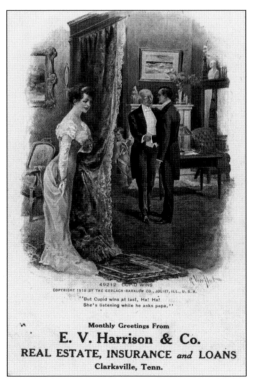

This beautiful 1910 Victorian card was used for advertising by E.V. Harrison and Company, which was in the businesses of real estate, insurance, and loans. Victorian cards enjoy a great deal of popularity among female postcard collectors.

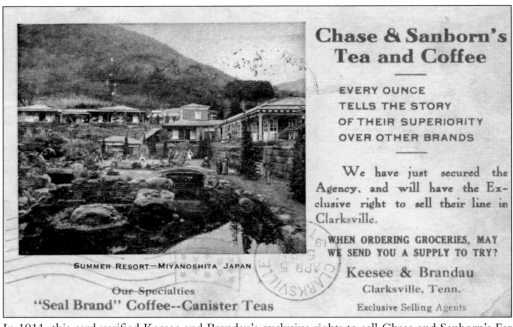

In 1911, this card verified Keesee and Brandau's exclusive rights to sell Chase and Sanborn's Far Eastern imported teas and coffee in the Clarksville area. Today you can buy these products on the Internet. The card was addressed to Mrs. James Hamlett in Clarksville.

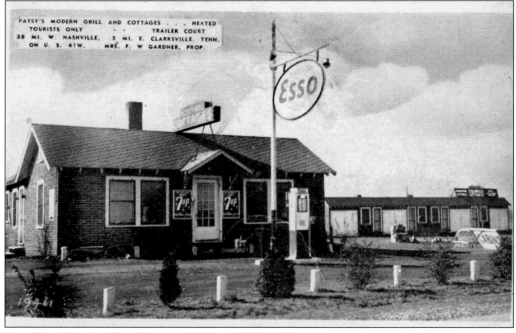

Patsy's business, under the management of Mrs. F.W. Gardner, once stood near Roosevelt School. The ball field was just to the left of Patsy's. This area is now the site of the Montgomery County school district's bus maintenance facility.

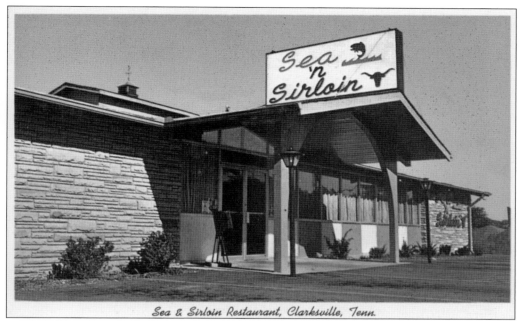

Sea & Sirloin Restaurant, Clarksville, Tenn.

Jack Fagan managed a restaurant in the old Montgomery Ward Shopping Mall, and Shirley Fagan operated a nut specialty shop in Sears. In the 1970s, they opened Sea and Sirloin on Riverside Drive. Previously, the building had been home to Ed Welker's Appliances and Beef and Sea Restaurant. Sea and Sirloin was a favorite feeding spot for the Cumberland River Rats who often came by boat to enjoy the good food.

This is probably how the Allens felt as the city repeatedly annexed more businesses out Highway 41A North, forcing the company to relocate (simply across the street on one occasion) to stay outside the city limits. While Allen Fireworks was finally "grandfathered" in, the controversy about fireworks inside city limits is still hotly contested. Allen's original owner died in a plane crash.

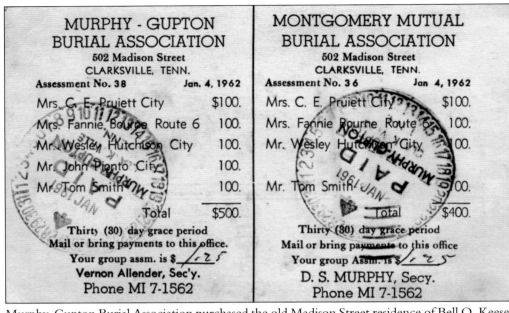

MURPHY - GUPTON BURIAL ASSOCIATION	MONTGOMERY MUTUAL BURIAL ASSOCIATION
502 Madison Street CLARKSVILLE, TENN.	502 Madison Street CLARKSVILLE, TENN.
Assessment No. 38 Jan. 4, 1962	Assessment No. 36 Jan 4, 1962
Mrs. C. E. Pruiett City $100.	Mrs. C. E. Pruiett City $100.
Mrs. Fannie Bourne Route 6 100.	Mrs. Fannie Bourne Route 6 100.
Mr. Wesley Hutchison City 100.	Mr. Wesley Hutchison City 100.
Mr. John Pionto City 100.	
Mr. Tom Smith 100.	Mr. Tom Smith 100.
Total $500.	Total $400.
Thirty (30) day grace period Mail or bring payments to this office. Your group assm. is $ 1.25 Vernon Allender, Sec'y. Phone MI 7-1562	Thirty (30) day grace period Mail or bring payments to this office. Your group Assm. is $ 1.25 D. S. MURPHY, Secy. Phone MI 7-1562

Murphy-Gupton Burial Association purchased the old Madison Street residence of Bell O. Keesee for this business. The Murphys and their daughter, Patricia, lived there for a period of time. The building is now Union Planters Bank. The nine individuals listed on the card have $100 burial insurance each and pay $1.25 a month for that coverage.

POST CARD

This space may be used for correspondence This space for the address only

The Most for Your Money

There's a great big difference in coal. You don't get dirt in ours. You get full weight and it's *all* coal. We want you to give us one order, because we know you will come back for more—you will get perfect coal and full weight every time.

This is a mighty good month to put in your coal—before the cold weather actually arrives.

Clarksville Ice and Coal Co.
Phones 80 and 65
Clarksville, Tennessee

Dr. S. Jefferson

City

Clarksville Ice and Coal Company sold ice in the summer and coal in the winter. The author obtained four of these cards from Jack Paisley in 2004. The images on the cards feature naval scenes from World War I, and the backs carry interesting advertisements. In 1917 and 1918, the company's phone numbers were 80 and 65. All four cards were sent from the Commerce Street business to Dr. S. Jefferson of Clarksville.

Three

CHURCHES
AND SCHOOLS

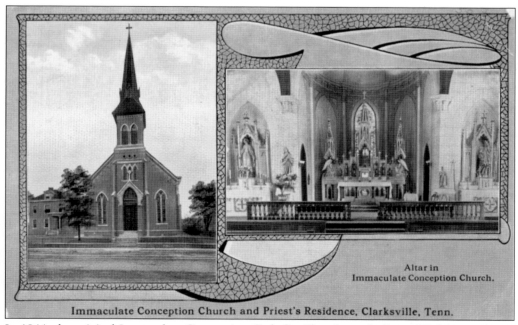

Altar in
Immaculate Conception Church.

Immaculate Conception Church and Priest's Residence, Clarksville, Tenn.

In 1844, the original Immaculate Conception Catholic Church was built on Washington Street (now College Street), but it later moved to 716 Franklin Street. At the time, there were few Catholics in Montgomery County. In 1975, a larger church was established and included the bell brought from Ireland for the 1844 church. Saint Mary's School, located on the church grounds, closed in 1968 and reopened on Madison Street in 2000.

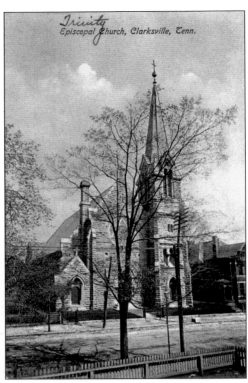

The present Trinity Episcopal Church, on the same site as the previous one, was completed about 1875. It was built of New Providence limestone with stone trim from Bowling Green, Kentucky. In 1856, slaves were earning $1,300 yearly while the rector here earned $800. The steeple was severely damaged by the tornado of 1999, and a new 60-foot steeple was lifted into place in May 2000. The church is on the National Register of Historical Places.

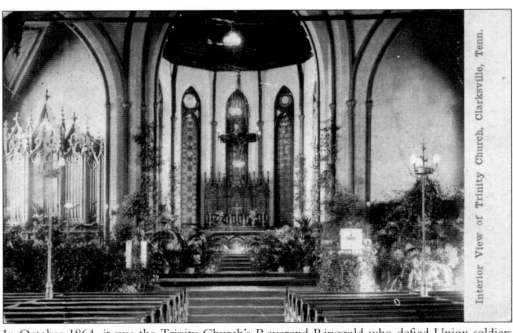

In October 1864, it was the Trinity Church's Reverend Ringgold who defied Union soldiers and presided over the public burial of 17-year-old Confederate Charles Lurton. Trinity Episcopal Church's interior is ascetically pleasing and includes four Tiffany stained-glass windows.

Clarksville's Presbyterians organized in 1822 and completed this First Presbyterian Church in 1878. The structure was located at Third and Main Streets. The church had a 2,790-pound bell, a $3,500 water-powered organ, and pews that could be rented by worshipers. There is a time capsule on the premises to be opened for the church's 300th anniversary in 2122. The T&W Pawn Shop, once located directly across the street, is often seen in photographs of the church.

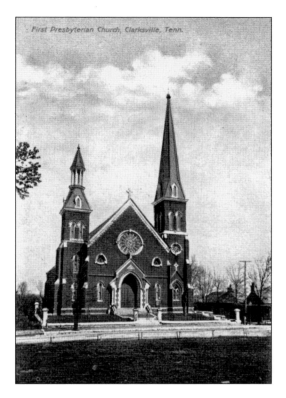

First Presbyterian Church, Clarksville, Tenn.

The cornerstone for Madison Street Methodist Church was laid in 1882. Until the tornado of 1999, the church looked remarkably unchanged. This card was sent to Mrs. William T. Steele in Changchow, China, in 1925. The message states, "This picture was taken for the Miss. Conference."

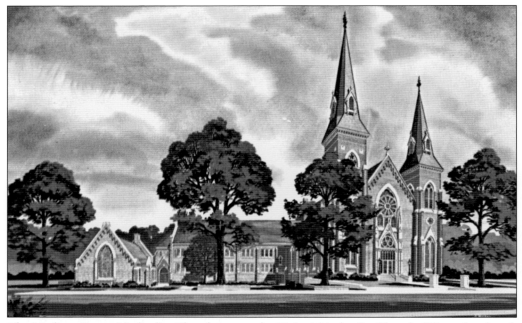

The Madison Street Methodist Church is now the United Methodist Church. When the church was destroyed by the 1999 tornado, all that remained were the bases of the original towers and portions of the chapel and educational building. Two asymmetrical gothic revival towers (145 and 129 feet tall) were replaced with copper-clad, structural steel outlines of the original towers. The new pipe organ, with its 3,000 pipes, came from the Czech Republic.

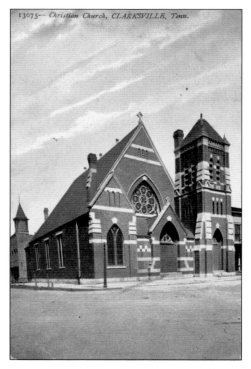

The Christian Church at South Third and Madison Streets was built in 1851. The church served as a tuition school for young boys during the Civil War. In 1890, a group of members formed a short-lived Church of Christ. For a number of years, the church managed a Clarksville mission for the black community. Hitching posts are visible on the left side of the church.

This First Baptist Church was razed in 1917 to allow construction of the current church at 435 Madison Street. Dr. John Laida of Shady Bluff was pastor of the current church for 27 years before retiring in 1987. Phenomenal growth, both in membership and budget, occurred under his leadership.

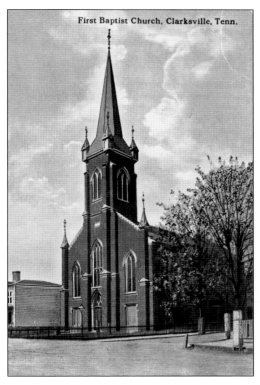

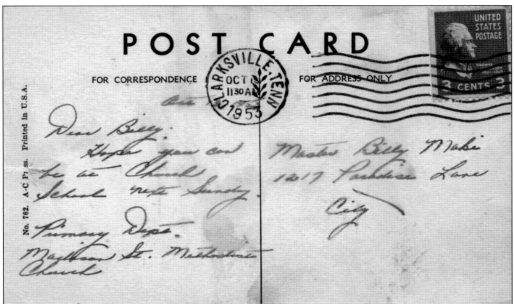

Madison Street Methodist Church's primary department sent this invitation to a young Billy Maki. Bill, now retired from Fort Campbell, lives in Italy with his lovely wife, Beverly. Bill's father and other family members still live in Clarksville. Many churches used postcards for invitations and reminders.

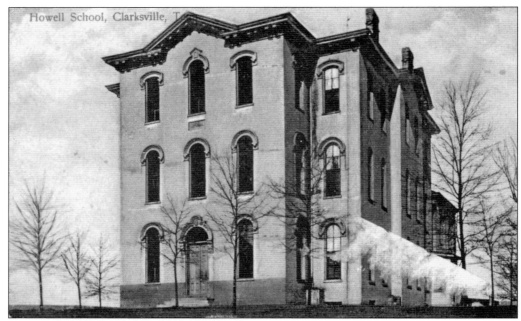

Howell School, Clarksville, T...

Howell School was Clarksville's first public school, and, as was common in those days, the school had separate stairways for boys and girls. The size of the trees and absence of a water fountain installed after 1895 suggests this is an early card. There are more than a dozen postcards with various views of this school.

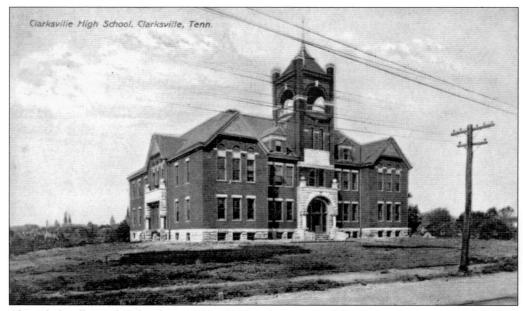

Clarksville High School, Clarksville, Tenn.

This Clarksville High School opened in 1907 at the corner of Greenwood Avenue and Madison Street. Unfortunately, the school burned in 1916, and it was then rebuilt. In 1969, students moved to the new high school. The building later fell into a state of neglect and was often vandalized before new owners converted it into Greenwood Place Apartments.

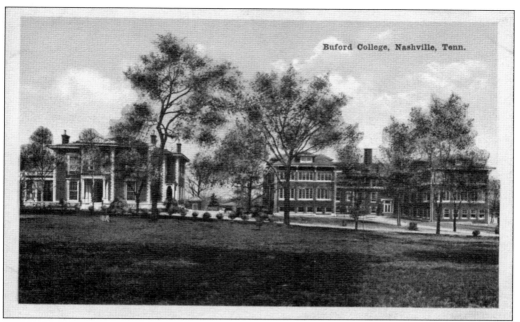

After 15 years with her Women's Academy in Clarksville, Mrs. E.G. Buford opened Nashville's Buford College in 1905. Buford College was a university preparatory school located on Caldwell Lane and dedicated to the "higher culture of women."

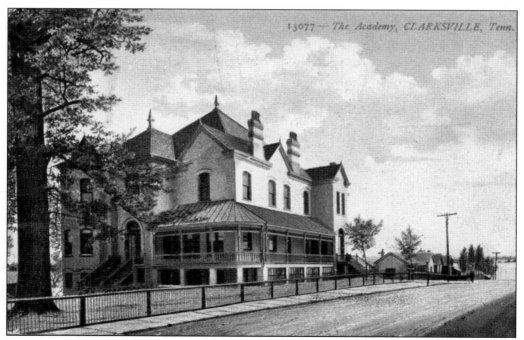

This second Clarksville Female Academy, located at Academy Avenue and Madison Street, was affiliated with the Methodist Church. Elizabeth Burgess (later Mrs. E.G. Buford) managed the school in the 1880s and 1890s.

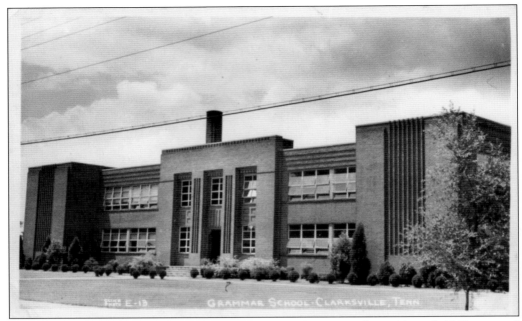

W.M. Cline, a Chattanooga photographer who was famous in the 1930s and 1940s, created this real photo postcard (E-13) of the Clarksville Grammar School, also known as Greenwood Elementary and Greenwood Annex. Cline created thousands of postcards of the South. While the author has only located two Cline cards of Clarksville, the photographer's numbering system suggests there are others. Except for an addition, this building looks much the same today.

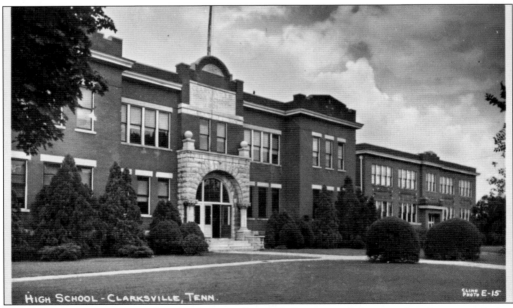

The original Clarksville High School, located at 300 Greenwood Avenue, lost its tower during the fire of 1916. After the fire, it was remodeled and an annex was added, and it eventually became Greenwood Place Apartments. This is another W.M. Cline real photo postcard (E-15).

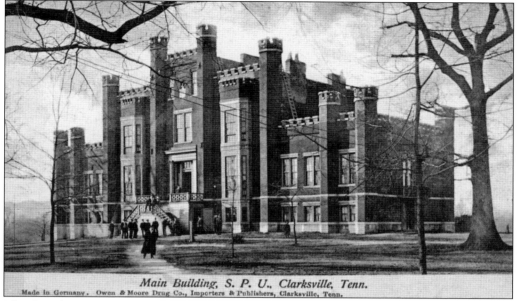

Main Building, S. P. U., Clarksville, Tenn.

Made in Germany. Owen & Moore Drug Co., Importers & Publishers, Clarksville, Tenn.

The "Castle" was erected in 1850 on College Street and was later a part of Southwestern Presbyterian University. It was a four-story, Elizabethan castellated building with 10 hexagonal towers. In 1946, a portion of it collapsed and it was razed. Three years later it was replaced with Austin Peay State University's (APSU) Browning Building.

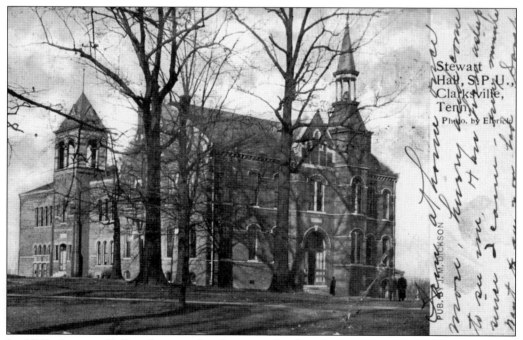

In 1875, Stewart College became Southwestern Presbyterian University (SPU). Stewart Hall was named in honor of school president William M. Stewart. Dr. J.R. Wilson, father of Pres. Woodrow Wilson, was a professor of theology at SPU.

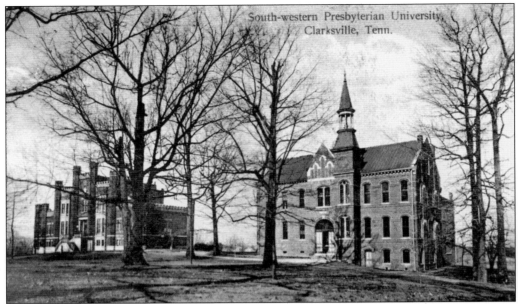

Southwestern Presbyterian University was established in 1875 at the corner of College and Drane Streets, where the Rural Academy and other institutions of higher learning had stood. The private university announced on September 13, 1917, that it would open its doors to all young women of Clarksville and Montgomery County who were qualified. The school moved to Memphis in 1925 and today is Rhodes College.

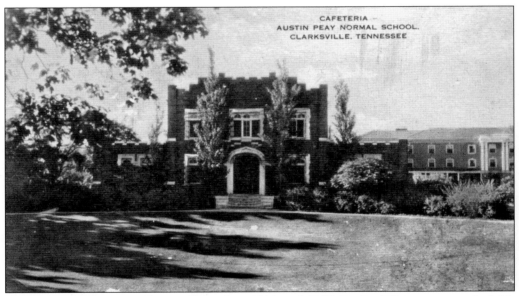

This APSU structure served as a cafeteria from 1916 until 1957. Dr. Joe Filippo was promised this building as a theatre, but it burned in 1967 and he was provided with a new theatre. The author traveled to New York City to acquire this card and 300 other Tennessee postcards and original negatives, which were discovered in a loft apartment once owned by Artvue Postcard Company, New York City.

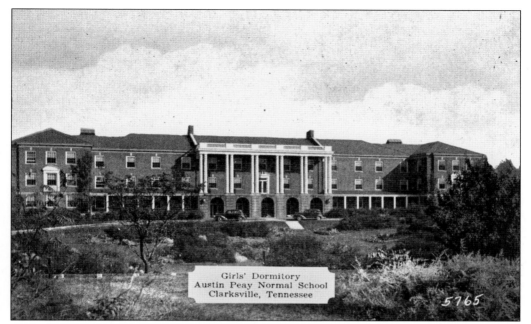

Girls' Dormitory
Austin Peay Normal School
Clarksville, Tennessee

Harned Hall, named for Myra McKay Harned, was completed in 1932 and was APSU's first female dorm. It is the oldest building on campus and the only remaining structure from Austin Peay Normal School. Rescued from the wrecking ball in 1987, it was renovated and is now home to university offices.

The APSU library was intimately familiar to many alumni, including Dr. Monte A. Gates, who is renowned for his worldwide work in the field of neuroscience. The author and other not-so-famous alumni spent time in a nearby pub also known as the "Library." Years later, it would be redesignated " 'brary."

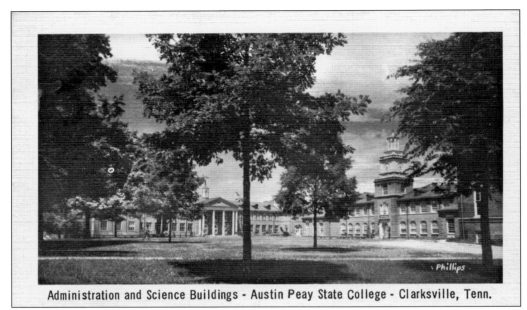

Administration and Science Buildings - Austin Peay State College - Clarksville, Tenn.

Dr. Haskell Phillips of the Austin Peay State College art department created four postcards of the campus in the 1950s. Dr. Phillips resided in Clarksville until he passed away in the late 1990s.

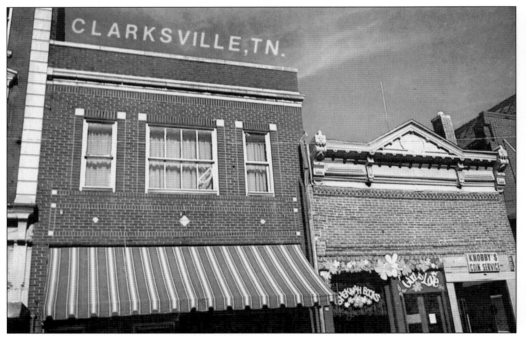

APSU art professor Dr. Bruce Childs published a series of four cards of downtown Clarksville for the 1984 Clarksville bicentennial celebration. This is one of the four he presented to the author in 2003. Dr. Childs retired in 2004. Knobby's Coin Shop, seen on the right, would later move to New Providence.

Four

PEOPLE AND RESIDENCES

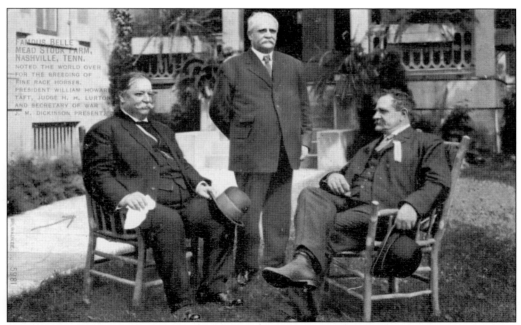

Pictured from left to right are President William Howard Taft, Clarksvillian Horace H.Lurton (1844–1914), and Secretary of War J.M. Dickinson. Lurton's home, built at the intersection of Madison and South Second Streets in 1874, was destroyed by the 1999 tornado and is now the site of the law offices of Cunningham, Mitchell, Patton, Peay, Rocconi, and Pittman. Lurton is buried in Greenwood Cemetery.

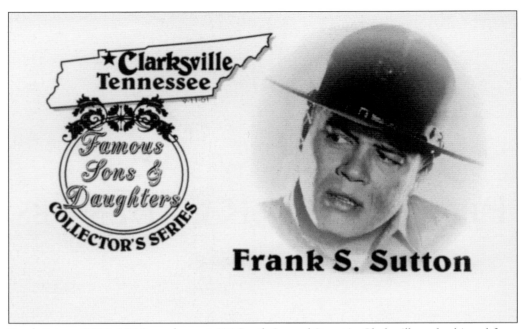

Frank S. Sutton

Frank Sutton (1923–1974) was born at 416 South Second Street in Clarksville and achieved fame as drill sergeant Vince Carter on the 1964 to 1969 sitcom *Gomer Pyle, U.S.M.C.* Both of his parents were employees of *The Leaf-Chronicle*, and his father was a broadcaster for WJZM in 1942 and 1943. Frank Sutton is buried in Greenwood Cemetery.

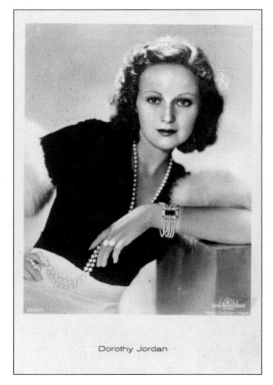

Dorothy Jordan

Dorothy Jordan (1908–1988) grew up on Tenth and Madison Streets, attended Clarksville High School, and achieved Hollywood fame in the 1920s and 1930s. She married movie mogul Merian C. Cooper, became pregnant, and lost co-star status beside Fred Astaire. A lesser-known actress named Ginger Rogers took her place. Jordan often visited Clarksville from Hollywood.

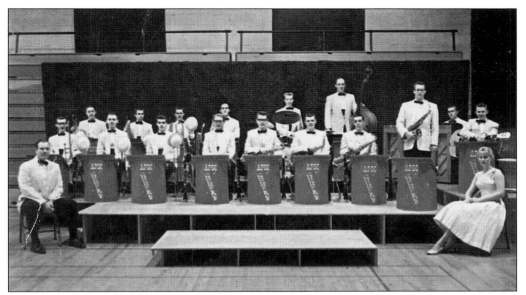

Dr. Solie Fott identified the following college students from left to right: Larry Womack, Tommy Miller, Bobby Graves, James Milam, Bobby Smith, Bill Burks, Mike Chilcutt, Jim Briney, Terry Turney, David Hall, Paul Garrison, Dan Dill, unidentified, Sid Burton, Mickey Garland, Arron Schmidt, Dick Strickler, and Helen Landrum.

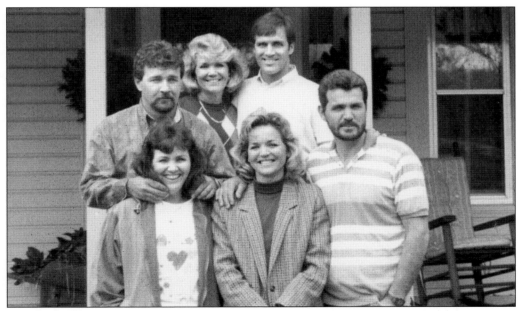

The following members of the Morrison clan are pictured from left to right: (front row) Saredia, Viola, and Shane; (back row) Buck, Evelyn, and Alabama. All but Evelyn attended Clarksville schools. Real photo postcards of families became possible in the early 1900s when Eastman Kodak Company introduced a camera and postcard size paper for developing pictures. Real photo postcards were extremely popular for the next 30 years but are rarely created today.

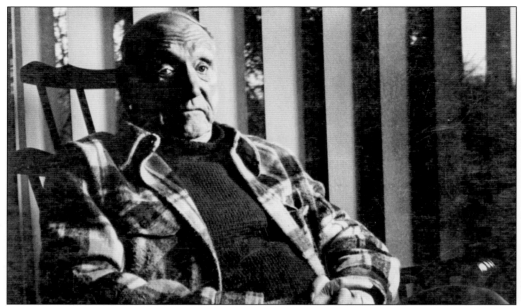

As a teen, Robert Penn "Red" Warren (1905–1989) commuted from Guthrie to Clarksville and attended Clarksville High School. He authored more than 30 literary works. While serving as Clarksville's official speaker for the bicentennial celebration in 1984, he conducted a poetry reading at APSU. In 1986, he was selected as the nation's first poet laureate.

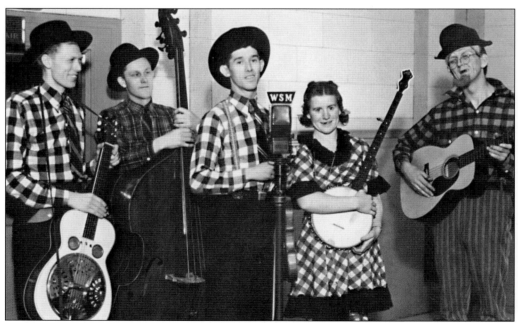

Roy Acuff (1903–1992), center, was a longtime friend of Clarksville mayor Charles Crow and owned Dunbar Cave from 1948 until 1966. Before his band became the Smoky Mountain Boys, they were the Crazy Tennesseans. He was a longtime emcee for the Grand Ole Opry and Republican nominee for governor in 1948.

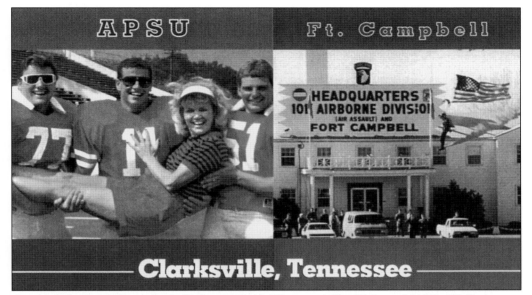

On the left, Austin Peay football players Hugh Thomas, Mike Blair, and Eddie Walls support an attractive fan. On the right, a Golden Knight brings the colors to the commanding general at Fort Campbell headquarters. This card was printed from photographs taken by the author in the early 1980s.

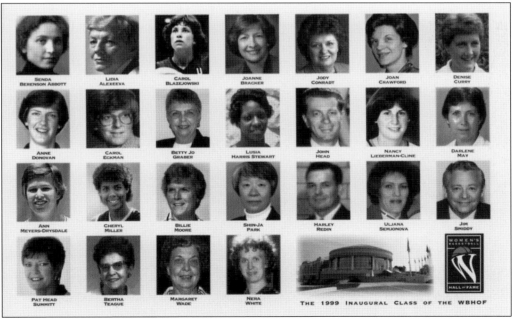

Pat Head Summitt, in the lower left corner, was one of 25 pioneers who helped shape women's basketball. She was enshrined in the inaugural class of the Women's Basketball Hall of Fame in 1999. Pat was raised in Henrietta, played on the 1976 Olympic team, coached the 1984 Olympic gold medal team, and in 1997–1998 coached the University of Tennessee women to a perfect 39–0 record.

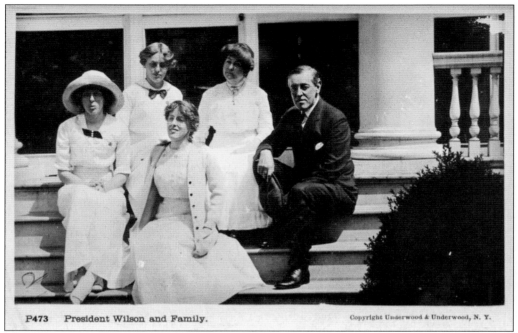

While Woodrow Wilson (1856–1924) did not live here, his family did. He visited Clarksville after the death of his mother in 1888. His father, Dr. J.R. Wilson, was a professor of theology at Southwestern Presbyterian University in the 1880s. Woodrow's brother Joseph Jr. attended SWPU. The family resided at 304 South Second Street near the corner of Munford Avenue.

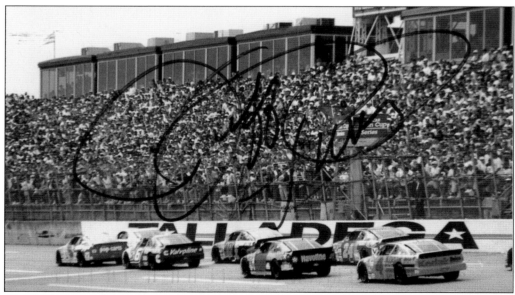

NASCAR fans will recognize this track as Talladega Super Speedway and know the driver of the Kodak car is Jeff Purvis. When Jeff became the #4 car driver in 1995, he already had over 350 victories in every kind of stock car imaginable. A serious racing accident in 2002 put his driving career on hold until 2004. Jeff resides in Clarksville and autographed this card.

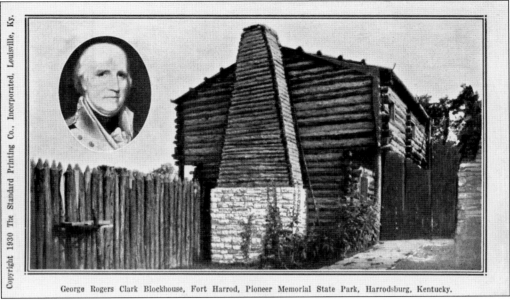

George Rogers Clark Blockhouse, Fort Harrod, Pioneer Memorial State Park, Harrodsburg, Kentucky.

Clarksville was named for the great frontiersman and Revolutionary War hero George Roger Clark (1752–1818). The city was part of the western frontier then, and Clark was a hero to people here; however, his accomplishments were unknown to many in the East.

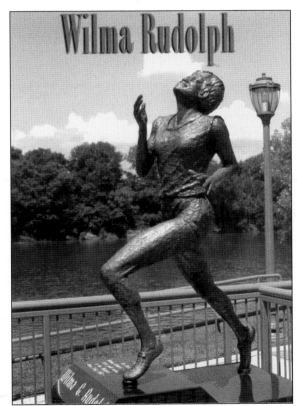

Wilma Rudolph (1940–1994), one of 22 children, contracted polio as a child but at age 20 was the world's fastest woman; Wilma won three Olympic gold medals in 1960. Sadly, she died prematurely of a brain tumor. In conversations the author had with Wilma, she stated, "I have made Indianapolis my home."

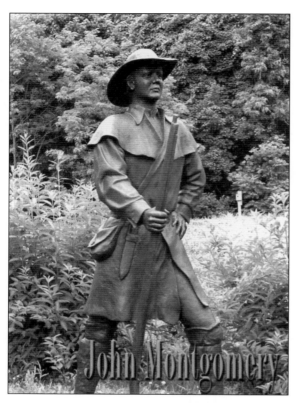

John Montgomery (1722–1808) had little formal education. He first visited the future site of Clarksville around 1775. He chose the river's east bank for a settlement because of its accessibility by boat and the presence of a spring (found by following a buffalo trail) that would provide drinking water. Montgomery led attacks on Native Americans at Nickajack and Running Water near Jasper, Tennessee, and was killed by Native Americans near Eddyville, Kentucky.

APSU professor emeritus Max Hochstetler and a number of his art students created the large hand-painted murals in Opryland Hotel. He worked from Polaroid snapshots and the project took more than two years to complete. Max is pictured on the stepladder and art student Terry Thacker is on the scaffold. The faces in the scenes are real people from APSU and Clarksville.

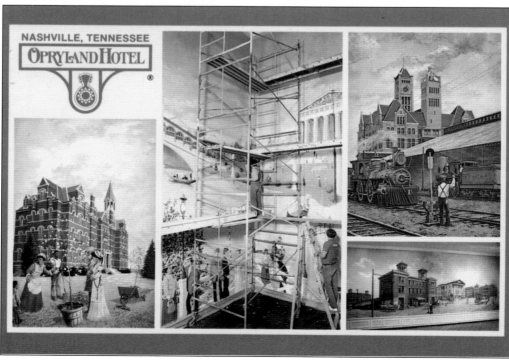

Leanne Teeple was a Clarksville High School cheerleader who graduated in 1984. She is shown here on a nostalgic spring break in Panama City, Florida. Leanne attended APSU and was employed by the Tennessee secretary of state before moving away from Clarksville.

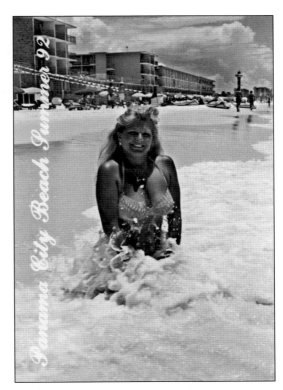

This card served as a Christmas greeting from Brig. Gen. George Hatton Weems (1891–1957), founder of Weems Academy. His better-known brother, Phillip Van Horn Weems (1889–1979), invented numerous navigational systems and was an All-American football player, Olympic wrestler, and friends with Charles Lindbergh and Orville Wright. The Weems boys, who were orphans, grew up in Clarksville. Many members of the Weens family still live here.

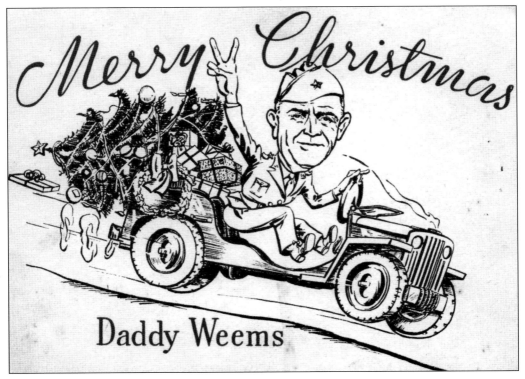

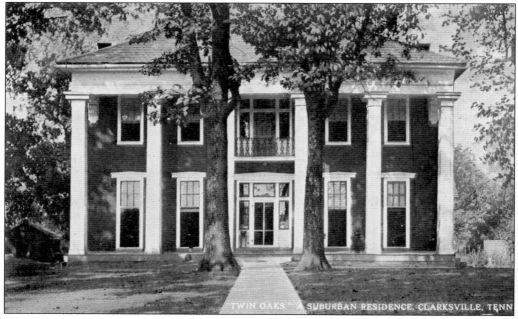

"TWIN OAKS" A SUBURBAN RESIDENCE, CLARKSVILLE, TENN

Twin Oaks is thought to have stood across from Greenwood Cemetery. Today, there is a residential area near Ussery Road with the same name.

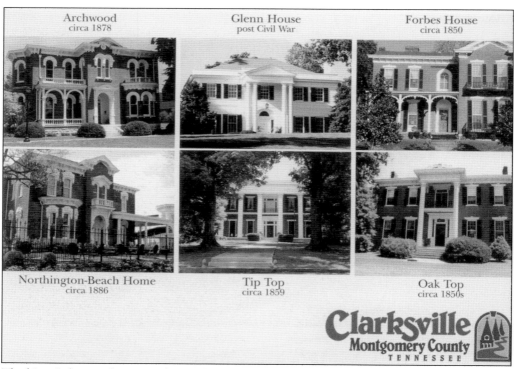

Archwood
circa 1878

Glenn House
post Civil War

Forbes House
circa 1850

Northington-Beach Home
circa 1886

Tip Top
circa 1859

Oak Top
circa 1850s

Clarksville
Montgomery County
TENNESSEE

The historic homes shown on this card, created by Michelle Dickerson, are lived in today and are featured in the *Drive Clarksville Historic* audio tour. This is one of a set of nice modern cards.

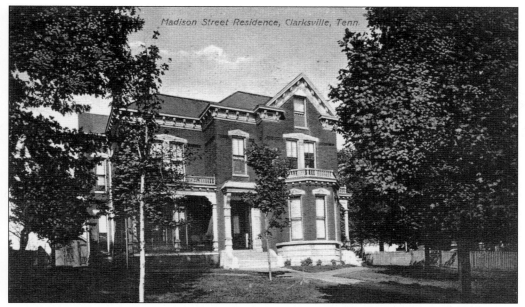

According to Eleanor Williams, county historian, this Madison Street residence was the home of H.C. Merritt (mayor 1870–1871). It closely resembles photographs of the home of Dr. Robert A. Webb and has much of the elaborate woodwork of the Rexinger home built on College Street in 1878. It is possible the same contractors built all three homes.

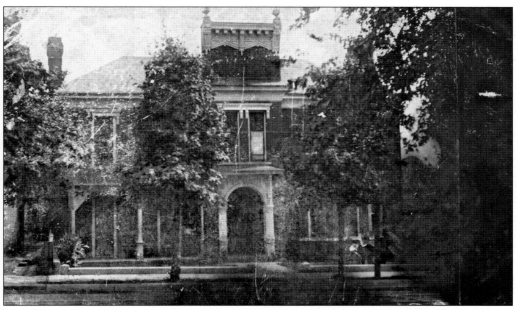

This Clarksville residence was the home of John Tisdale Batson and Anna Laura Pruitt Batson. They were the grandparents of Clarksville attorney Dick Batson, who recalls wonderful times in the home as a youngster. Sidney Batson had a shop in the portion of the home to the left. This card was sent to Dick's father, Fred Batson, in 1911. At the time, Fred was 18 years old and staying at the Maxwell Hotel in Paris, Tennessee.

While this residence is thought to be located in St. Bethlehem, neither the exact location nor owner are known. In 1912, it was home to E.H.F., who mailed this real photo postcard to E.B. Fontaine in Berkeley, California.

Lucy and Christopher H. Smith built the Smith-Trahern Mansion in 1858. After he died of yellow fever while in New Orleans, the steamboat returning his body to Clarksville exploded and his remains were never found. This is where Ruybe Patch and Joe Filippo guided the *Dinner with the Lively Dead* in 2004. Connie Judd was married here, and Russell Reeves's family was the last to live here.

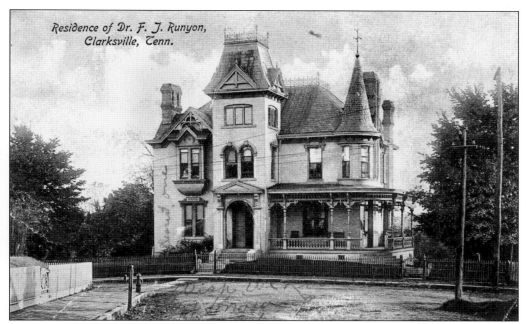

Residence of Dr. F. J. Runyon, Clarksville, Tenn.

This 1908 card shows the Union and Third Streets residence of L.G. Wood, who married Huldah Belle Warfield from Todd County, Kentucky. Their daughter Mable married Leslie Cheek of Nashville, thus the Cheekwood estate. It was later the home of prominent Clarksvillians Dr. Frank Jasper and Brenda Runyon. They were the grandparents of local attorney Frank Runyon, who remembers the home well. It is currently the site of the Clarksville Moose Club.

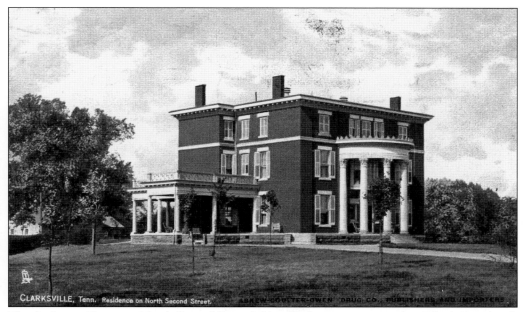

The Anderson Home on North Second Street is identified on some postcards as King's Daughter's Hospital. It served as Clarksville Hospital for 27 years. It then became home to the Clarksville Academy before being torn down in 1982. This is a Raphael Tuck card.

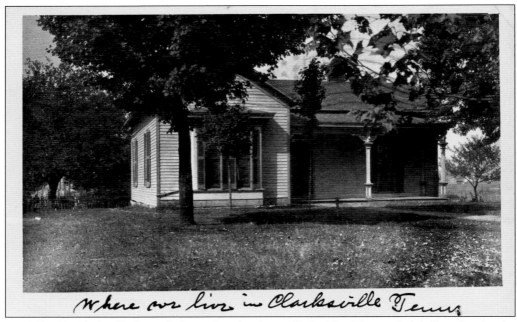

Where our live in Clarksville Tenn

In 1908, this Clarksville home belonged to the sister of Miss Elva Thayer. It is believed to be the home of the Cookman family, but its location is uncertain.

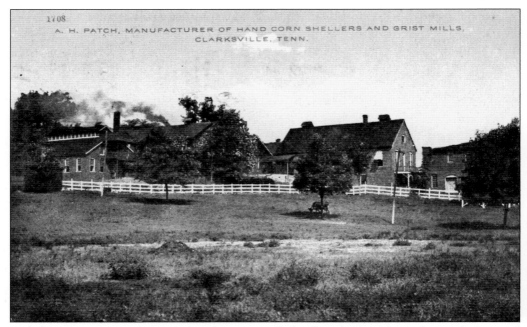

1708

A. H. PATCH, MANUFACTURER OF HAND CORN SHELLERS AND GRIST MILLS, CLARKSVILLE, TENN.

Asahel Huntington Patch (1825–1909) came to Clarksville in 1875. This is the Patch farm and factory near the site of APSU. Patch patented the Black Hawk corn sheller in 1886, and it was produced and distributed until 1954. Most farms in the county still have one, and antique collectors value them.

Five

RIVERS AND RAILROADS

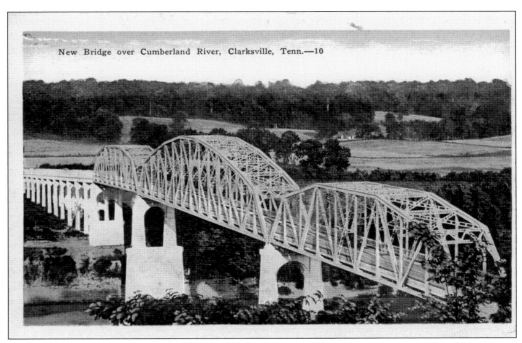

New Bridge over Cumberland River, Clarksville, Tenn.—10

Cunningham Bridge, constructed by the Nashville Bridge Company, was completed in 1924 at the site of the old Gaiser's (Gaisser's) Ferry. The triangular patterns distributed weight, allowing heavy loads to use the bridge. Designated a K-truss bridge (note the K configuration in center section) it was one of only two known to exist in Tennessee. On September 25, 1986, it was demolished by T.O.I. Corporation to make room for the current bridge.

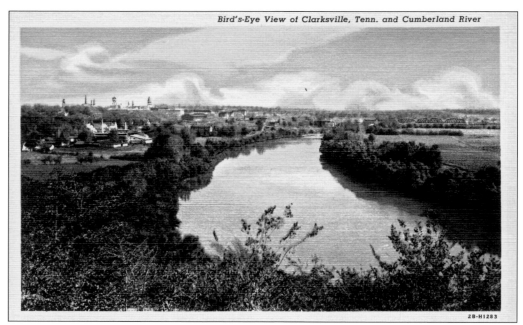

This bird's-eye view of Clarksville and Cumberland River is presented on a linen postcard. The photograph was taken from the old fort above the Red River. Clarksville is on the left and the rich bottomland beneath Cumberland Heights is on the right. This area is the burial site of thousands of Native Americans from the Mississippian Period.

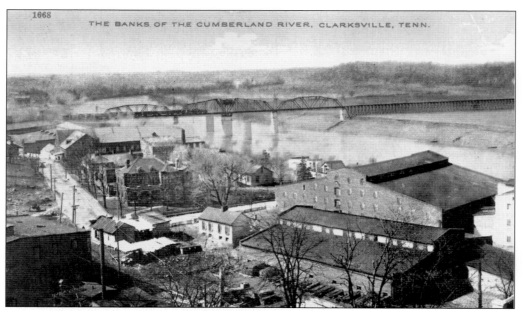

THE BANKS OF THE CUMBERLAND RIVER, CLARKSVILLE, TENN.

This card of the banks of the Cumberland River is postmarked 1912. The train is crossing the L&N turn bridge, and Elephant Warehouse can be seen in the foreground; the warehouse was located at the corner of Commerce and Front Streets. The old jail is in the center of the picture. The street on the left that runs toward Commerce Street became Sullivan Street.

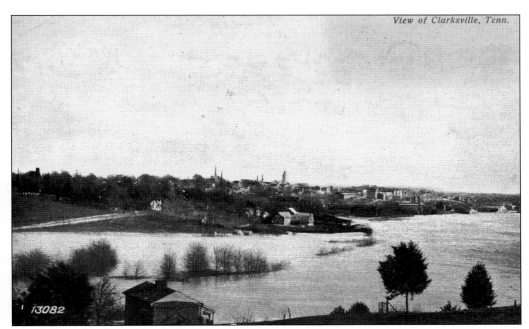

13082

Note in this view of Clarksville the many small islands that dotted the Cumberland River before dams and dredging eliminated them. Until the dams were built on the Cumberland River, it often flooded or was too shallow for navigation. Toward the end of the Civil War, the Union flagship *Cincinnati* had to remain in Clarksville because of the low water level of the river.

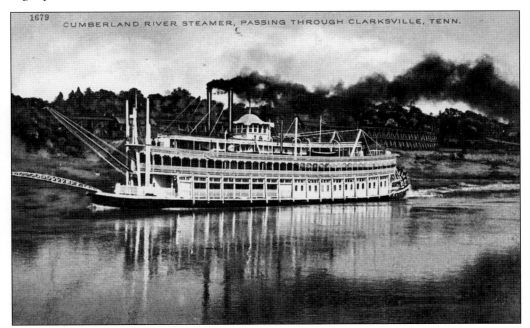

1679
CUMBERLAND RIVER STEAMER, PASSING THROUGH CLARKSVILLE, TENN.

This Cumberland River steamer is an excursion steamboat, unlike the smaller packets (mail-carrying boats) owned and operated by brothers Frank and Matt Gracey of Clarksville. This postcard, postmarked 1916, shows a railroad trestle in the background.

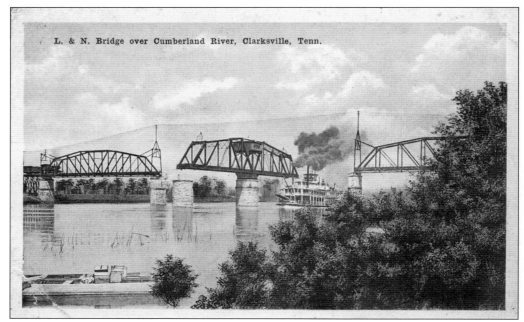

L. & N. Bridge over Cumberland River, Clarksville, Tenn.

The L&N bridge was built too low in 1859, and riverboat stacks were routinely torn off as boats went under the bridge; it was rebuilt in 1861. This view shows a steamer going past the bridge and a small commercial fishing boat in the foreground. The L&N turn bridge is on the National Register of Historic Places as a part of the Clarksville Industrial District.

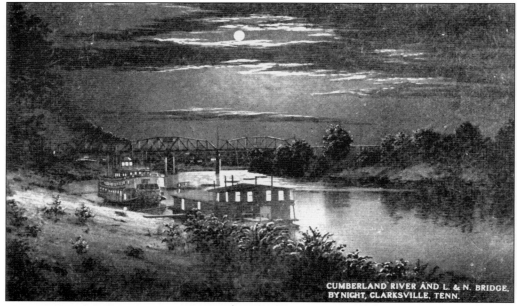

CUMBERLAND RIVER AND L. & N. BRIDGE.
BY NIGHT, CLARKSVILLE, TENN.

The Cumberland River has always been a major navigation and trade artery. This night view of a docked steamer and houseboat shows the L&N turn bridge in the background. The site is across Riverside Drive from where Red's Bakery is today. S.H. Kress and Company printed this card, but a similar postcard printed in Germany shows the identical view during daylight hours.

Cumberland river, navigable all the year. Louisville & Nashville railroad, also Illinois Central, gives us the lowest freight rates. Largest snuff factory in the world. 180-ton iron furnace. Large lumber interests. Furniture factory, collar-pad factory, 1200-bbl. flour mill, largest dark tobacco market in the world, Southern headquarters for American Tobacco Co., pearl button factory. Other factories building. We want more. Write Secretary Chamber of Commerce for particulars.

River Front, Clarksville, Tenn.

Clarksville's Chamber of Commerce published this early card. The structure in the foreground (possibly a houseboat) has the number 173 painted on it. The message on this 1914 card addressed to Cornelius Spencer in Merchantville, New Jersey, states, "father sent them three hampers of apples."

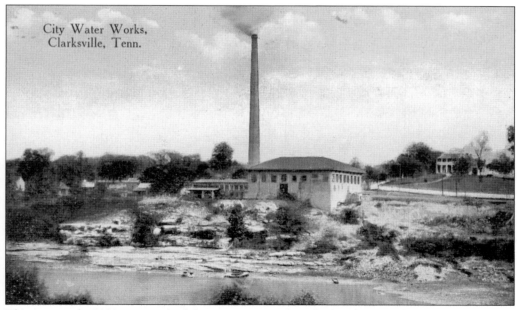

City Water Works, Clarksville, Tenn.

This is an early 1900s postcard of the city waterworks. The building on the hill to the right is the old Current residence. During the 1937 flood, townspeople built a protective dike around the waterworks building. In the 1970s and 1980s, it was a popular lounge frequented by young Clarksvillians, APSU students, and Fort Campbell soldiers. Patrons could enter the lower lounge by way of a slide.

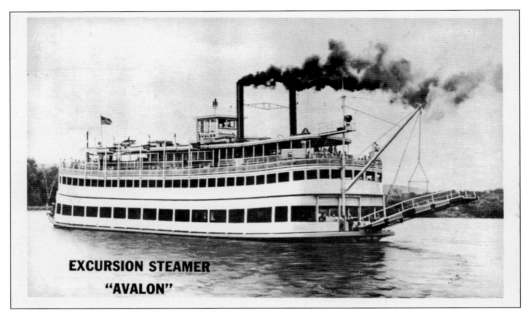

EXCURSION STEAMER "AVALON"

The *Avalon* was built in Memphis in 1914 and was originally the ferryboat *Idlewild*. Later, she served as a packet and towboat before becoming a day tramp (migrating from port to port). Finally, she was an excursion boat, and, during the 1950s and 1960s, Clarksville High School seniors and their dates boarded her to the sound of the calliope. Few relics remain today from the multitudes of steamboats that plied the river in the 1800s.

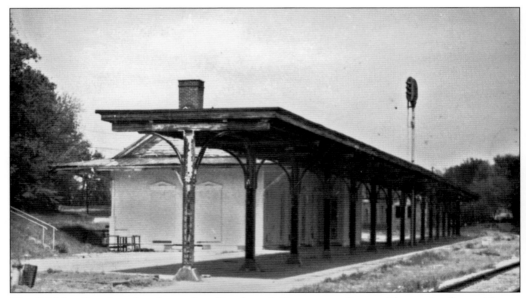

The L&N railroad station located at Tenth and Commerce Streets (shown in disrepair) was constructed in the 1880s and is Clarksville's second railroad station. There were ladies, general, and African-American ("colored") waiting rooms available. In 1966, the last train from Clarksville left here making its way west; the Monkees immortalized it in song. The station now houses the Montgomery County Historical Society.

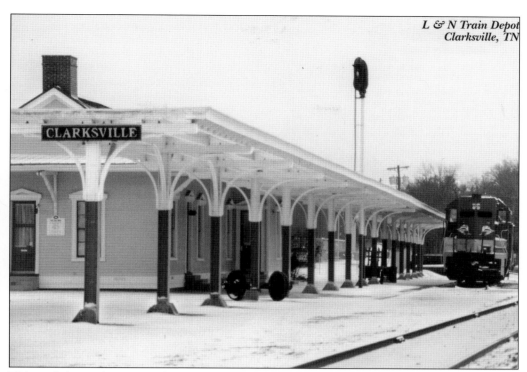

L & N Train Depot
Clarksville, TN

This card shows the L&N railroad station after the 1996 renovation that was part of the state bicentennial project. P.O. Bledsoe was the last ticket agent there, and his sister, Mrs. Eleanor Rogers, worked there during World War II with her uncle, E.S. Gilliam. The Gilliams were originally from Stanton. The station closed in 1966 though employees remained at the depot until the 1970s. It was purchased by the City in 1982.

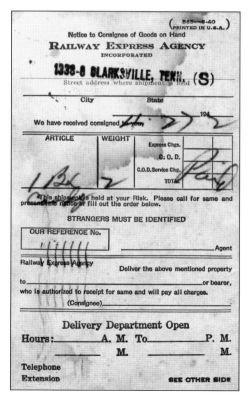

The Railway Express Agency Incorporated used this 1942 Clarksville postcard as evidence a two-pound box of candy was shipped to Mrs. T.J. Willard, R # 4, City. Addresses on earlier cards often contained only a name.

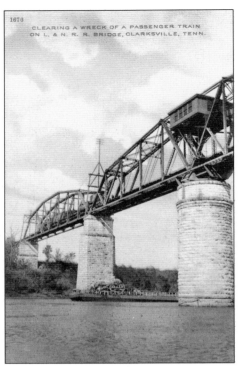

An L&N locomotive plummeted from the turn bridge into the Cumberland River on September 29, 1906. Frank Porter, the engineer, and Will Wood, express manager, were both killed. Wood's body was recovered five days later 62 miles downstream. The engine was retrieved, refurbished, and put back in service. The mail car was recovered a month later, and mail was delivered. A strikingly similar incident occurred on June 13, 1947.

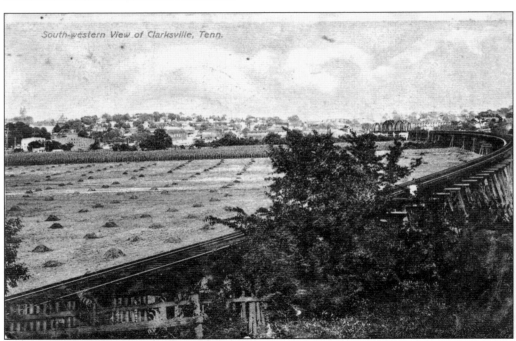

This southwestern view shows the horseshoe bend and trestle leading to the L&N turn bridge and into Clarksville. The Memphis, Clarksville, and Louisville Railroad opened the trestle in 1862. It was sold to the L&N after the Civil War.

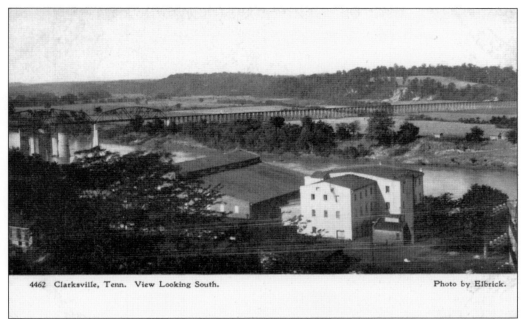

4462 Clarksville, Tenn. View Looking South. Photo by Elbrick.

This Clarksville view looking south shows the Elephant Warehouse in the center of the picture. The L&N turn bridge can be seen beyond that.

A railroad employee inspects a bridge near Clarksville on the Tennessee Central Railroad. Roadbeds and trestles were completed during 1902–1903, and the first train ran from Clarksville to Hopkinsville in 1904. The line also ran to Ashland City and Nashville. This is a real photo postcard dated 1915.

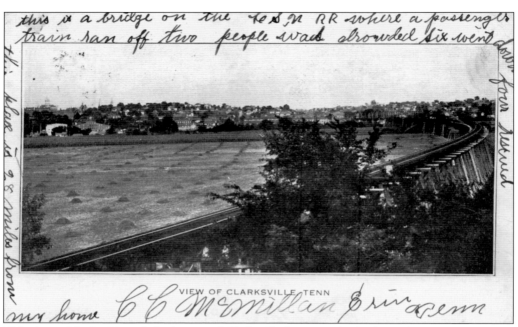

this is a bridge on the L&N RR where a passenger train ran off two people was drowned six went down from funnel

this place is 28 miles from my home C C McMillan Erin Tenn

VIEW OF CLARKSVILLE, TENN

This view of the L&N trestle looks toward Clarksville from Cumberland Heights. Close inspection shows a train coming westward. This stretch of track was known as Horse Shoe Curve. The tall crop growing in the bottomland is corn. There are several postcard variations of this scene; most are *c.* 1905–1920.

The Old L&N.

Linda K. Derossett © 1994

Linda K. Derossett made this fractured black-and-white photo of the L&N station, reorganized it, and finished it with colored pencils. The postcards were printed by Foto-1 of Clarksville.

70

Six

GOVERNMENT
AND COMMUNITY LIFE

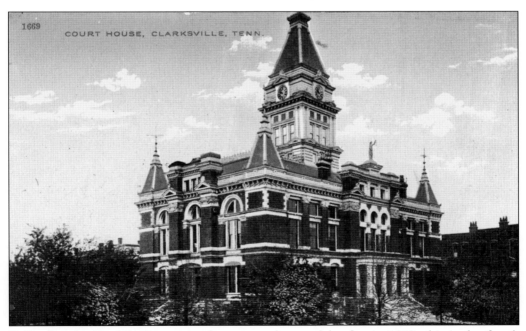

Built after the Franklin Street courthouse was destroyed by fire in 1878, this is the fourth courthouse in Montgomery County. The current structure was damaged in a 1900 fire and extensively damaged by an F-4 tornado in 1999. After the tornado, the building's exterior was restored and the interior was completely redesigned.

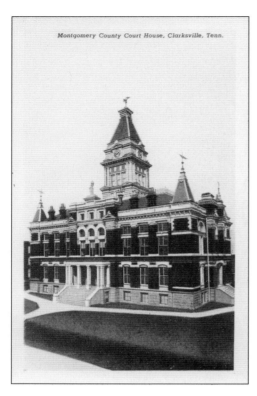

Montgomery County Court House, Clarksville, Tenn.

Several important events have occurred at this courthouse: Dr. Joshua Cobb, who had been mayor several times, died here after a passionate speech; in 1925, Henry Gregory made final payment on a mule then fell down the courthouse steps and died; the KKK rallied on the front steps; Dale Redman paid county trustee David Dabbs $587 worth of county taxes in pennies; and more recently, Brenda Radford, county commissioner, performed civil marriages.

The clock tower, eagle, Lady Justices, and corner spires were all damaged by the tornado of 1999. The grand opening of the renovated structure was delayed when carved stone from Bulgaria was late arriving. Dave Williams, one of the few photographers allowed into town after the tornado, took this photo. The courthouse in Davies County, Indiana, was built by the same contractors and was identical to this one.

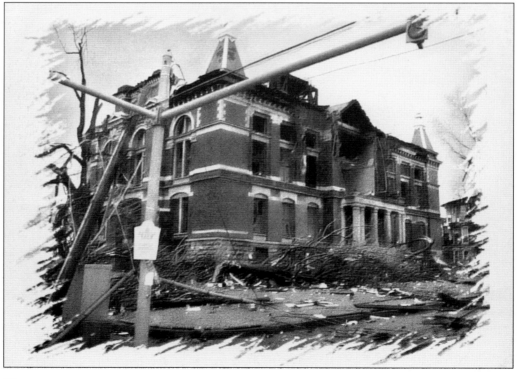

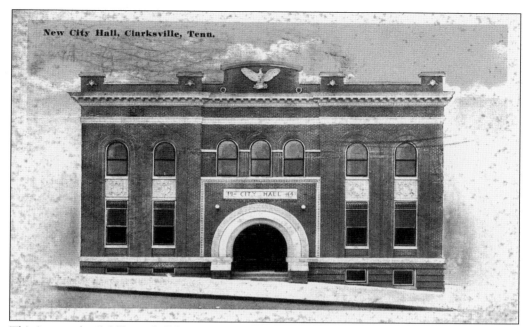

New City Hall, Clarksville, Tenn.

This is now the "old" city hall located at 110 Public Square. In 1971, J.D. Hanley sandblasted it to show the original brick. He also designed lanterns to replace light globes flanking the entrance in this image. Former mayor pro tem and long-standing city councilwoman Mary Jo Dozier recently persuaded the city council to keep the building. The eagle and roof decorations are no longer there.

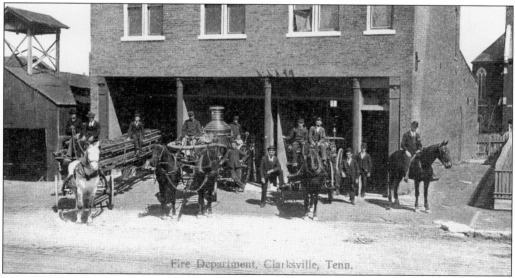

Fire Department, Clarksville, Tenn.

The Clarksville Fire Department was organized in 1878. This fire hall was located on the east side of South Third Street between Commerce and Madison Streets. The ladder wagon is on the left, a wood burning pumper is in the middle, and a hose wagon (now in the Clarksville Museum) is on the right. Horses were worked daily to maintain their strength; prior to the acquisition of horses, volunteer firemen drew the vehicles.

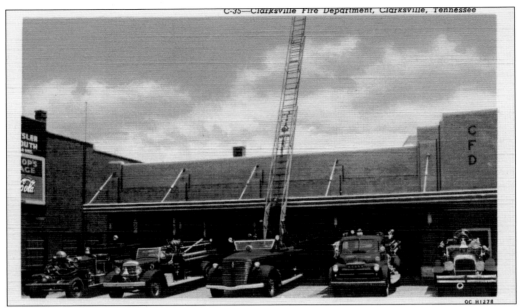

This is a postcard of the fire station that was built beside Dunlop's Garage in 1938 to replace the earlier station. In 1937, the Ahern Fox 750 GPM Pumper Truck (right) was tested on the courthouse square before the city agreed to purchase it. Testing criteria required that water be sprayed over the eagle atop the courthouse for 30 continuous minutes. Lt. Randy Rubel, years later, did much of the restoration of some of these vehicles.

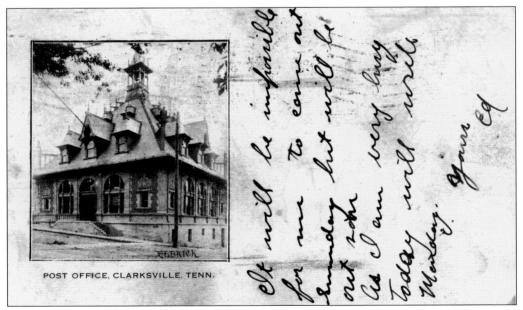

POST OFFICE, CLARKSVILLE, TENN.

Located at 200 South Second Street, this most unusual building was constructed in 1897–1898. Original building plans included a tower. The facility became necessary after a drastic increase in the volume of mail due to the thriving tobacco industry. This black-and-white card by Elbrick has an undivided back and required that any message be written on the front of the card.

74

The Customs House Museum and Cultural Center combines Italianate, Romanesque, gothic, and Eastern architectural styles. It was renovated in 1984.

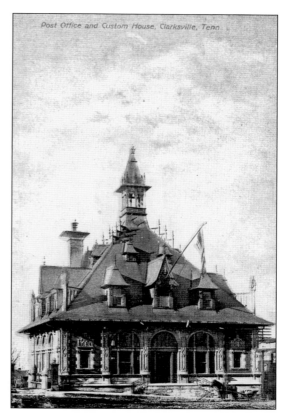

Post Office and Custom House, Clarksville, Tenn.

This is an artist's rendition of the downtown post office and is somewhat different from the actual structure. Attendees to its formal dedication on August 2, 1963, included Congressman Ross Bass, Postmaster General J. Edward Day, Sen. Estes Kefauver, Sen. Albert Gore Sr., Gov. Frank Clement, Mayor Charlie Crow, and Eagle Scout John Roe Jr. The post office employed eight rural letter carriers in 1963.

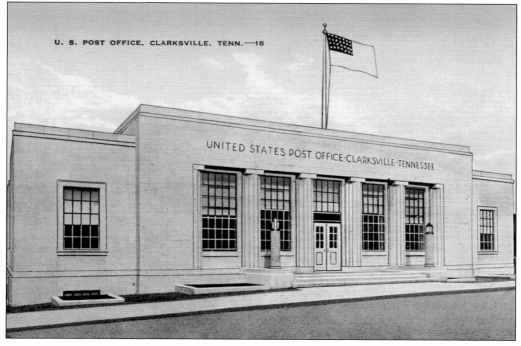

U. S. POST OFFICE, CLARKSVILLE, TENN.—18

UNITED STATES POST OFFICE·CLARKSVILLE·TENNESSEE

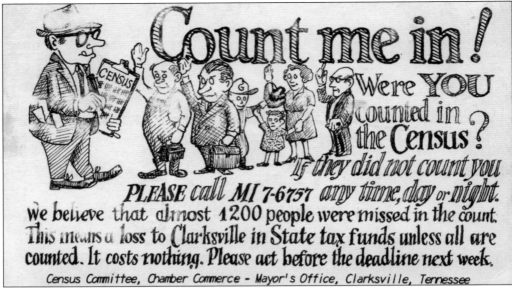

In 1960, this card was mailed to Harold M. Lester at 203 Maplemere to ask if he was counted in the census. This effort to ensure a total population count was a partnering of the Census Committee, Chamber of Commerce, and Mayor's Office.

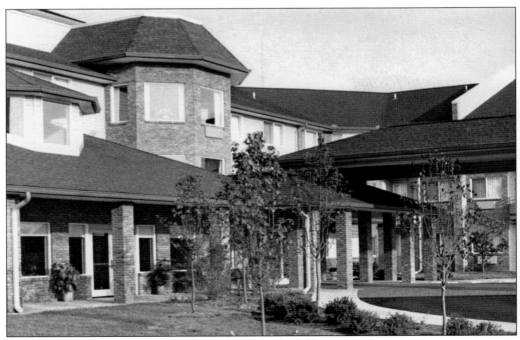

Uffelman Estates, a wonderfully managed retirement home, opened at 215 Uffelman Drive in 1992. Notable residents have included Gus Norfleet, Marion Moore, Opal Edmondson, and the late Clarence Davenport.

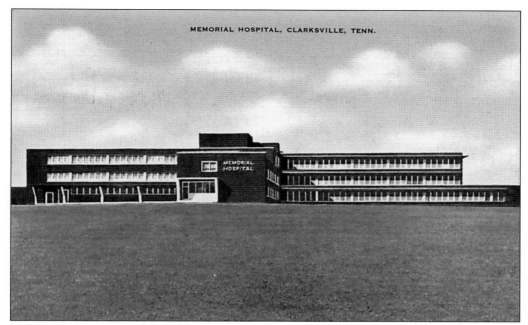

This card shows Memorial Hospital as it appeared when it opened in 1954. It represented a $2.5 million investment and was proclaimed a "city within itself." Doctors on the original staff included Jack Ross, V.H. Griffin, Ed Atkinson, Billy G. Lyle, Carlos Brewer, and Tom Iglehart. Charles M. Warren Jr. was a pharmacist there. Two auxiliaries—White Women's Auxiliary and Colored Women's Auxiliary—were organized to promote the hospital.

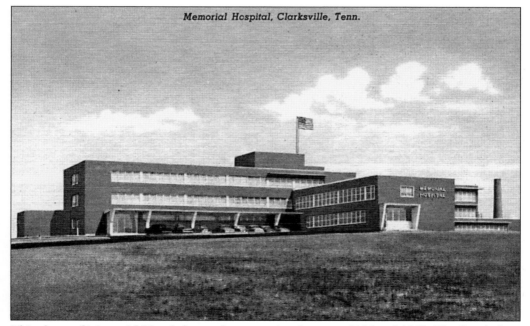

This photo of Memorial Hospital was taken sometime between 1954 and 1963. The fourth floor was added in 1963, and a helipad was built in 1976.

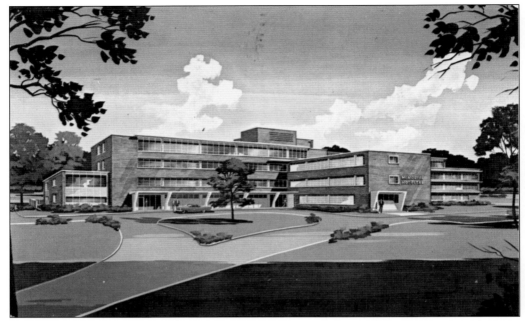

This artist's concept of the hospital is much the way it looked in 1994. In 1954, the cost of a room ranged from $7 to $14 a day; today rooms cost more than $425. Many Clarksvillians currently opt for treatment in Nashville hospitals. The hospital is now the Gateway Medical Center.

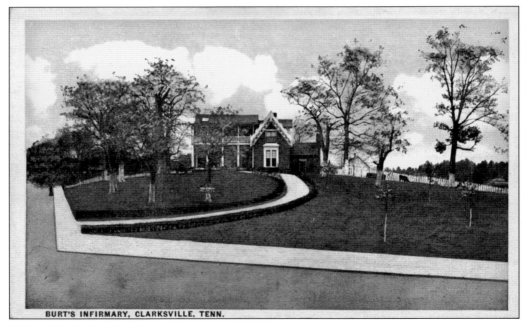

BURT'S INFIRMARY, CLARKSVILLE, TENN.

Dr Robert Burt, son of an ex-slave from Mississippi, came to Clarksville in 1902 at the age of 29 and married Clarksville native Emma E. Williams. In 1906, his infirmary on Current Street was Clarksville's first hospital. Dr. Frank Runyon assisted Burt with the first surgery procedure in the infirmary. Other white doctors operated the infirmary in Burt's absence.

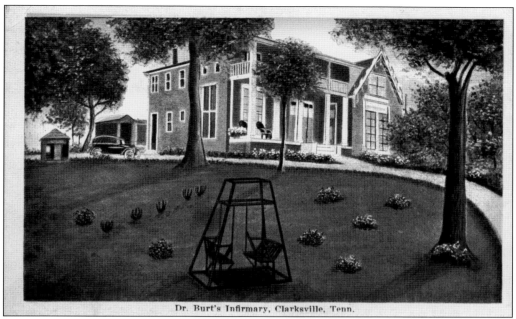

Dr. Burt's Infirmary, Clarksville, Tenn.

Dr. Burt was appointed by Governor Browning to represent the state at the centennial celebration of the African-American city of Mound Bayou, Mississippi. Having once performed 40 surgeries in a single day, by 1947, Burt was confined to a wheelchair and died on August 16, 1955, at age 81. In 1966, Mrs. Burt, who had been the doctor's nurse, still resided on the infirmary's first floor. The building burned in 1992.

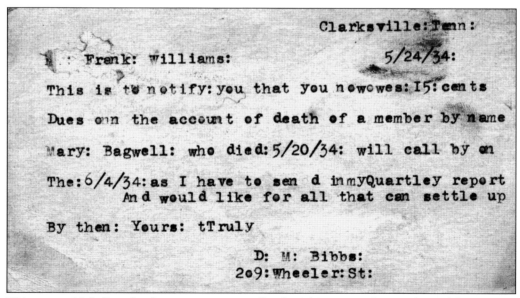

This postcard is believed to be a statement regarding burial insurance for members of the African-American community. Addressed to Mr. Frank Williams, RFD No. 2 Box 28, Clarksville, the card encourages payment due of 15¢. It states that Mrs. Mary Bagwell died on May 20, 1934, and D.M. Bibbs must complete a quarterly report.

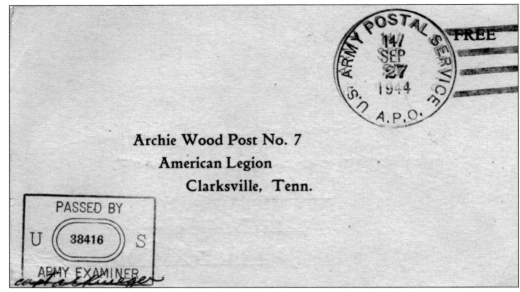

This card was free-franked and examined by the army during World War II. On the reverse, a soldier from Company B, Eighth Tank Battalion thanks American Legion Post Number Seven for sending him Chesterfield Cigarettes.

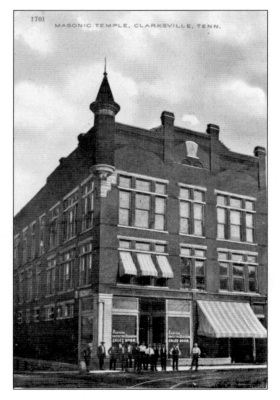

The Masonic Lodge, located at Third and Commerce Streets, was built around 1900 and collapsed August 12, 1949. The photograph of the collapse was considered spectacular for its time and photographer L.J. Dancey received considerable accolades for it. Lodge officials put themselves at risk to retrieve secret documents from the building after the collapse.

The Clarksville Country Club was organized in 1913 when 65 pear trees were up-rooted from an orchard and the course was designed. In 1946 and 1947, the links became an emergency airfield, when aircraft were forced to land there on two occasions. There are only two postcards known to exist of the Clarksville Country Club.

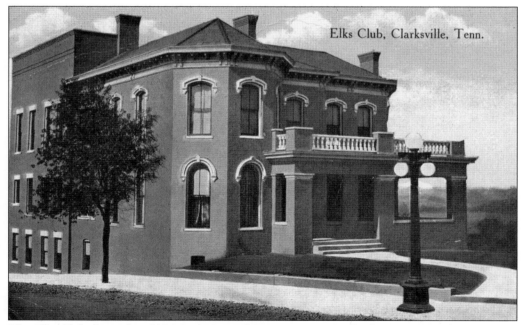

The Elks Club, located at 203 North Second Street, was originally the J.C. Couts home. It was purchased in 1921 by the Federation of Women and served as a library and club headquarters. In 1924, a historical department of the Federation of Women was established and came to be known as the Montgomery County Historical Society. The first county historian was Ursula Smith Beach.

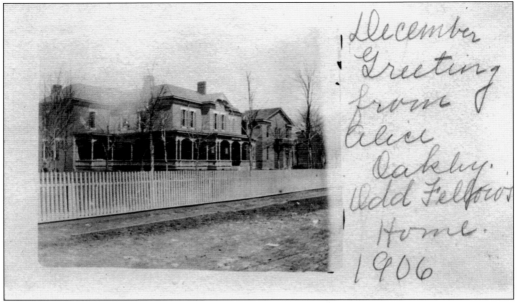

Vester Powers, Pat Edwards, Clay Stacker, and many other local residents resided at the Independent Order of Odd Fellows (I.O.O.F.) home shown here. Comparison of tree size in the various postcard images indicates this is the earliest card of the home. These divided-back cards appeared in the early 1900s, which is generally referred to as the golden age of postcards. This card from Alice Oakley, a resident of the home, is dated 1906.

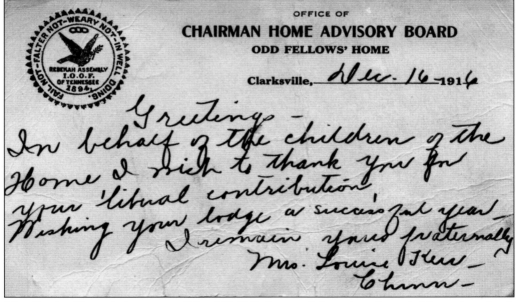

Mrs. Louise Kerr, chairwoman of the I.O.O.F. home advisory board, used this card to thank the Charlotte Rebekah Lodge 1382 in Cleveland, Tennessee, for a contribution. The card is postmarked December 18, 1916; this suggests that the contribution may have been related to the Christmas holidays.

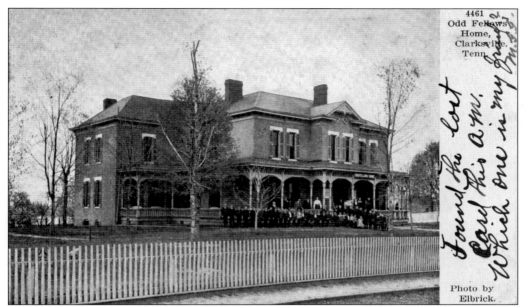

Located at the east end of Market (previously Walker) Street, the I.O.O.F. home consisted of three buildings operated by Pythagoras Lodge I.O.O.F. It served as both a home for the elderly and the orphaned. The home was operational from 1898 until 1946. This card shows 41 boys, 17 girls, and 9 adults. There are also chickens in the lower left portion of the yard. The home had a traveling uniformed band.

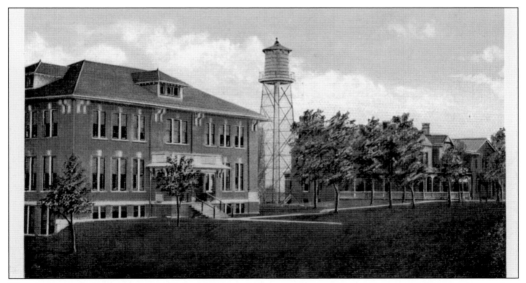

The I.O.O.F. Home was sold in 1952 and eventually fell into disrepair. When the author photographed it in 1999, homeless persons were occupying it. It was razed in 2004. Of 10 different postcard views in the author's collection, this is the only one that shows the water tower. High school aged children residing at the I.O.O.F. Home were bused to Clarksville High School for classes. One of those residents, Howard Johnson, went on to play football for the Green Bay Packers.

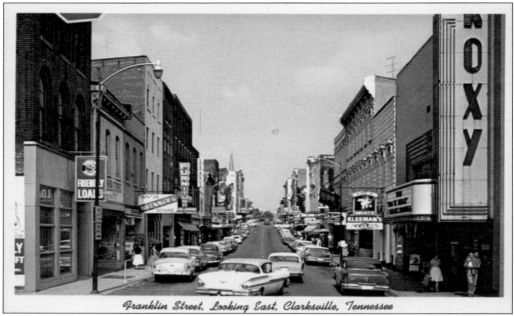

Franklin Street, Looking East, Clarksville, Tennessee

The Lillian Theatre burned in 1945, and a larger, modern, Art Deco–styled theater called the Roxy was opened in 1947. It ceased operations as a movie theater (called a "picture show" in the South) in 1981. While Sunday movies were legalized in Tennessee in 1934, Clarksville did not exercise that option until 1942.

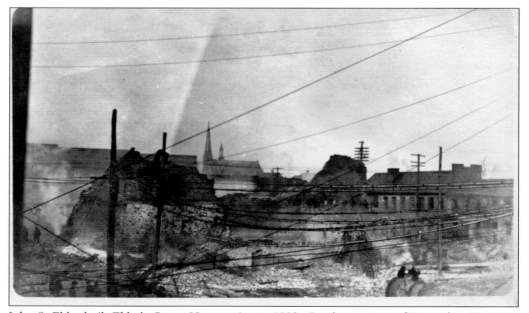

John S. Elder built Elder's Opera House prior to 1882. On the evening of December 29, 1914, fire destroyed this landmark, which stood at the corner of Franklin Street and Public Square. It was never rebuilt. This real photo postcard was developed in reverse. Montgomery County historian Eleanor Williams has a set of about 10 cards showing the smoldering remains of the opera house.

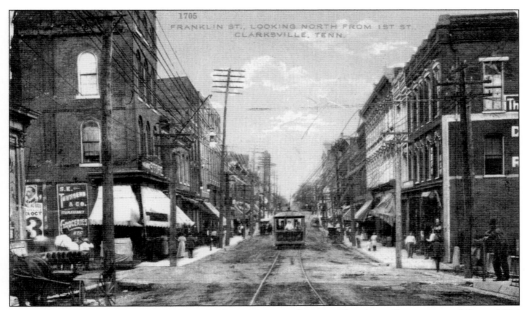

The trolleys seen here were horse drawn from 1885 until 1896. Electric trolleys operated from 1896 until 1927, when trolley service was discontinued. Based on the numbers of buggies and people on this postcard, it is likely this photo was taken on a Saturday. The photographer was looking east on Franklin Street, and the gentleman in the lower right is leaning on a hitching post.

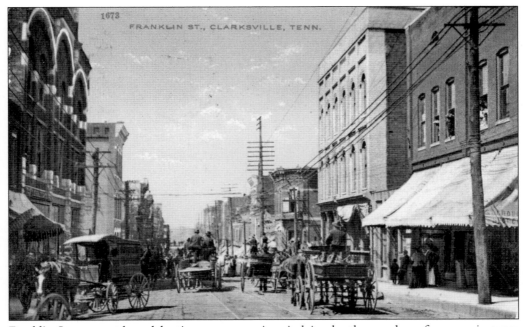

1673
FRANKLIN ST., CLARKSVILLE, TENN.

Franklin Street must be celebrating some occasion, judging by the number of wagons in town and the people looking out of windows. Trolley tracks are apparent in the street. The card is postmarked 1912, and the photographer was looking west on Franklin Street. There are many postcards of Franklin Street.

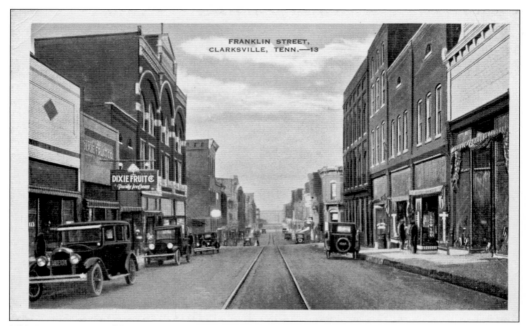

This is a 1920s Franklin Street scene looking east. In 1925, reckless driving caused the city to pass an ordinance restricting auto speeds to 15 miles per hour. Trolley tracks are still obvious, and the Dixie Fruit Company is seen on the left. Telephone poles shown in other Franklin Street cards are conspicuously missing in this one.

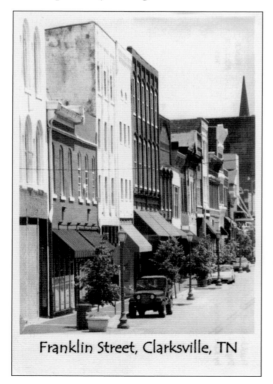

This is a digital print of a hand-colored photograph made into a postcard. This beautiful 1990s card is Karen Disbrow's work. Franklin Street continues to be the most vibrant part of downtown. This view is directly across from the Roxy Theatre and extends beyond Joy's Jewelers. Today, five of these buildings are vacant. The steeple in the background is that of the Episcopal church.

Seven

DUNBAR CAVE
AND SWAN LAKE

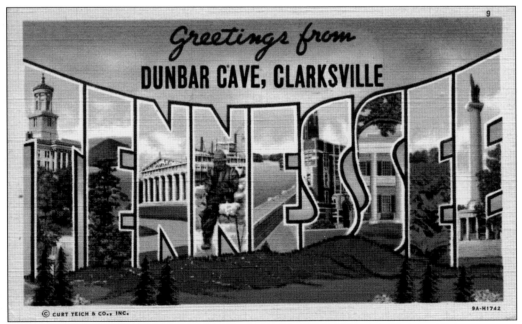

This "large letter" Dunbar Cave postcard was mailed in July 1941 and refers to the "worst drought in years." A different Tennessee view appears in each letter on the card. Names and addresses on this card have been masked, as is fairly common on postcards.

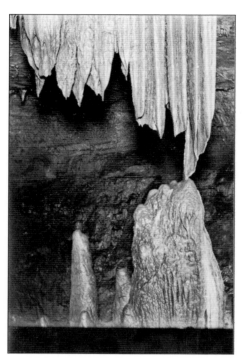

In Dunbar Cave, elaborate columns form as stalactites dropping from the cave's ceiling meet stalagmites rising from its floor. Items on the cave walls include a drawing of T.L. Martin, dated 1860; the name Walter Scott dated 1889; and Wayne Teeple's name, which he placed there when he was a tour guide for Spot and Gladys Acuff in the early 1950s.

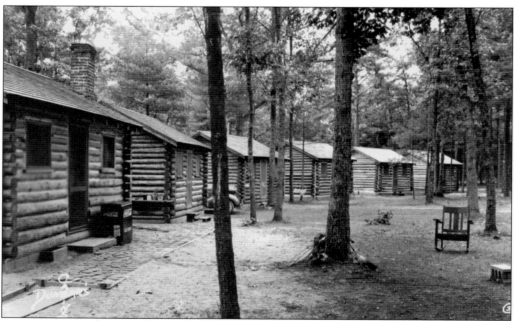

Little is known about Dunbar's cabins. Photos in old copies of *Cumberland Lore* show similar cabins near Idaho Springs as early as 1903 and as recent as the 1930s. Notice the Coca-Cola icebox by the cabin. Prior to 1948, Mayor Kleeman was part owner of this property. He was also proprietor of Coca-Cola Bottling Company, so it is no surprise that only Coke was available at the cave.

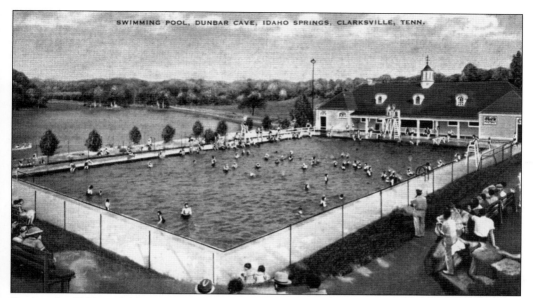

During the 1930s and 1940s, W.W. "Pappy" Dunn operated the cave. The pool was added in the early 1930s and closed in the 1960s when a number of municipal pools opened. The bathhouse was converted to the Visitor Center and Museum. It is said there was an earlier pool located near the middle of the lake. There are at least seven different postcard views of the pool shown here.

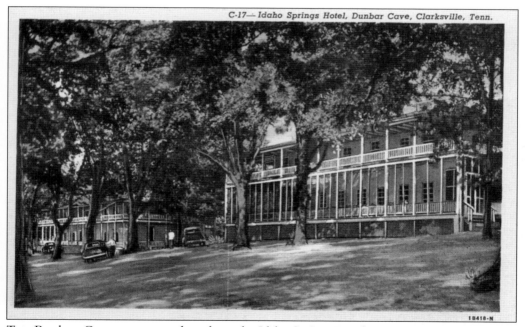

Tate Brothers Contractors started work on the Idaho Springs Hotel in 1912. It consisted of two buildings, one with rooms and the other for cooking and dining. Roy Acuff's brother Spot was operating the hotel in the early 1950s when it burned a second time. It was not rebuilt. Many Clarksvillians remember the Acuffs and the hotel.

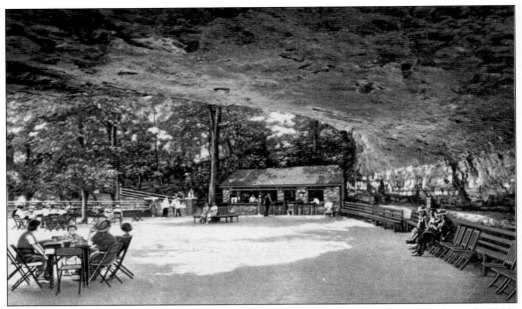

Dunbar Cave State Park is located on 110 acres at 401 Old Dunbar Cave Road. In the early 1930s and 1940s, the cave attracted large numbers of visitors because of the big bands and nationally known entertainers that performed there. The cave's natural air conditioning was also appealing to visitors. After World War II, the availability of mechanical air conditioning and television caused the cave's popularity to wane.

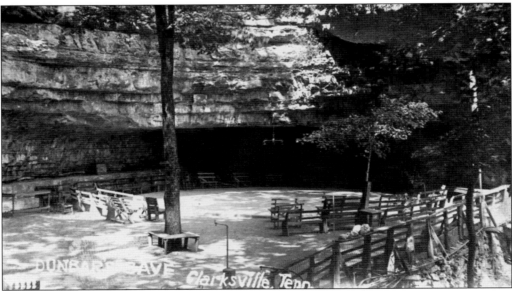

Dunbar Cave has over eight miles of surveyed passages, and virgin cave continues to be discovered. It is possible other caves in the area are all part of a major cave system that includes Dunbar. Bellamy, Bone, Coleman, Durham, Killebrew, and Woodson Caves are just a few of the caves in this area. Caves often have more than one name, and sometimes names change when property ownership is transferred.

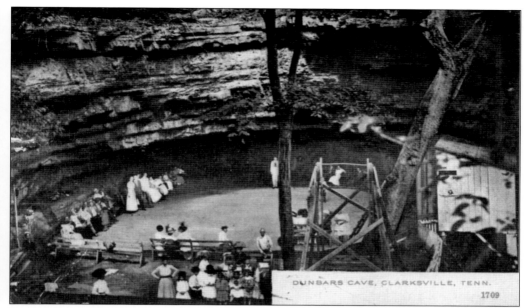

Dunbar Cave offered visitors many forms of entertainment; they could dance, enjoy boat rides and horseback rides, play bingo, watch fireworks displays, have picnics, or watch the peacocks and monkeys. There were always pretty girls at the pool and on the diving board—but there were no alcoholic beverages (at least, none were authorized.)

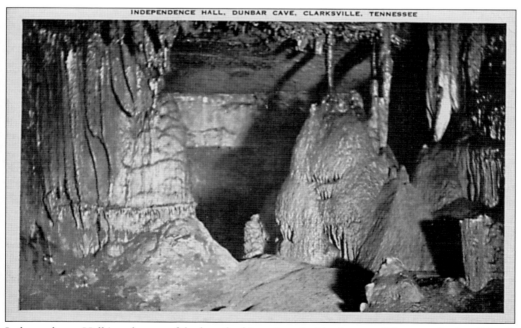

Independence Hall is only one of the breathtaking views inside the cave. The organization Friends of the Cave has truly lived up to its name. Members have volunteered their time to promote the cave, re-map surrounding trails using global positioning systems (GPS), create a website, eliminate invasive species of plants, and improve the Interpretive Center.

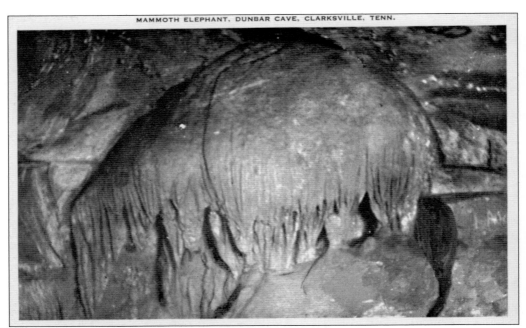

It is obvious why this odd formation was named Mammoth Elephant. Organized excavations have revealed that Native Americans used the cave for thousands of years before European explorers discovered it in the 1790s.

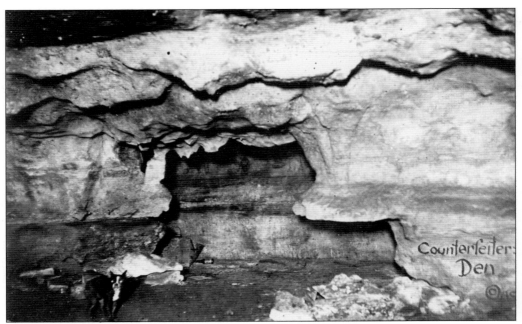

Such a band occupied Counterfeiter's Den in 1842. Fort Campbell Military may have used the cave during World War II and again in the 1950s. Vandals left their mark when they set fire to containers of oil placed there when the cave was used as a civil defense fallout shelter; resulting fires disturbed the bats living in the cave. Note the dog in the front left of this 1924 real photo postcard.

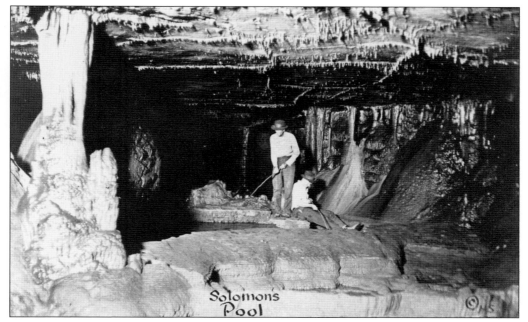

Solomon's
Pool

This most interesting real photo postcard from the summer of 1924 shows two men fishing inside the cave. The ruins of the old saltpeter works are located near Solomon's Pool. The National Speleological Society's golden rule of caving is, "Leave nothing but footprints, take nothing but pictures, kill nothing but time."

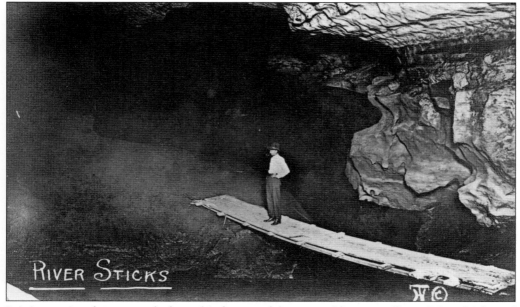

RIVER STICKS

It is interesting that postcards show this feature of the cave with two spellings, River Sticks and Styx. The old man in the photo is smoking a pipe, and the walkway is now gone. There are numerous and conflicting stories about nearby Peterson's Leap, but the most likely one is in the October 1988 issue of the *Cornsheller*.

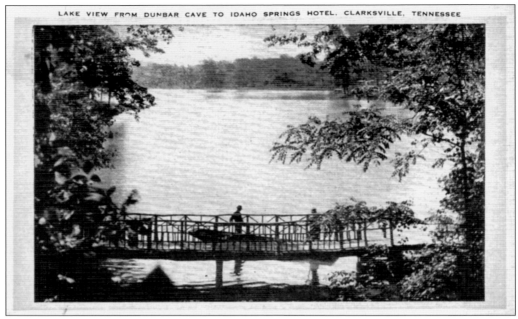

LAKE VIEW FROM DUNBAR CAVE TO IDAHO SPRINGS HOTEL, CLARKSVILLE, TENNESSEE

The metal pedestrian bridge was built to aid hikers; however, it is unknown when this bridge was removed. This card was printed about 1934.

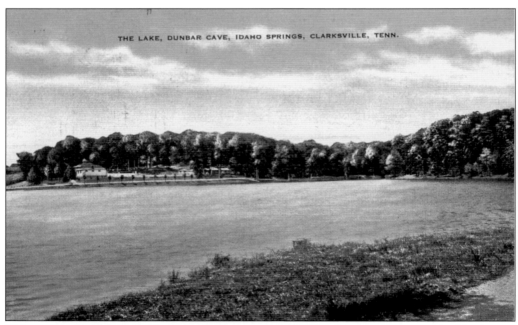

THE LAKE, DUNBAR CAVE, IDAHO SPRINGS, CLARKSVILLE, TENN.

This card (printed in both black–and–white and color) of Swan Lake was postmarked in August 1941. It includes an advertisement on the back that states, "General Admission 10 cents per person, parking free. Perhaps this season's last cave dance. Francis Craig and his WSM Broadcasting Orchestra." There are actually swans on Swan Lake.

In 1984, park officials drained the lake and posted the property to prevent trespassing. Regardless, people made their way across the muddy lakebed and netted large carp and catfish when only small pools of water remained. This is a color photograph that was made into a postcard and mailed to Alabama Morrison when he was participating in navy basic training at Great Lakes, Illinois.

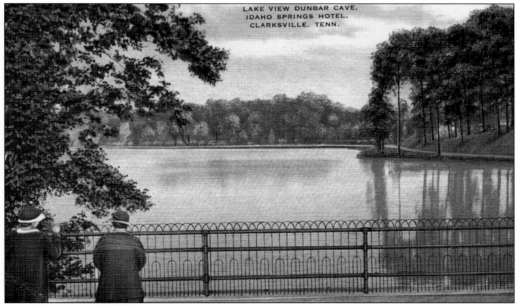

Ronnie Hunter and his teenage friends used to open valves on the dam and drain Swan Lake. On July 24, 2002, John Paul Baggett caught a 65-pound carp here. During Gov. Don Sunquist's term, he announced the closing of the cave to save money, leaving only park manager Bob Wells and Ranger Amy Wallace as full-time employees.

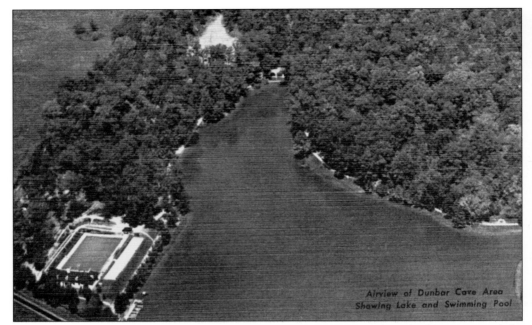

Airview of Dunbar Cave Area
Showing Lake and Swimming Pool

This linen postcard is a true aerial view, unlike many that are taken from building tops or hills. The beach and paddleboat pier can be seen in the lower left; the cave entrance is top center; it was not determined what caused the clearing to the left of the cave. While Waldo E. Rassas and Gerald Tenney are known to have taken aerial photos of Clarksville, it is not known who took this one.

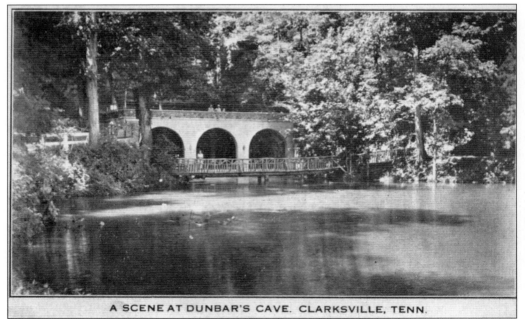

A SCENE AT DUNBAR'S CAVE. CLARKSVILLE, TENN.

This card, "A Scene at Dunbar's Cave," is one of a set of perhaps 15 cards by an anonymous artist. The postcards are black-and-white with a white border and have no information on the backs.

Eight

HOTELS AND MOTELS

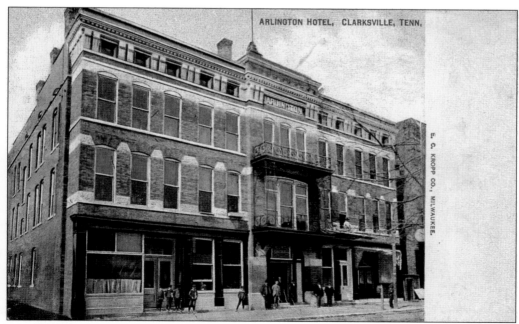

Arlington Hotel was built in 1887 and stood at 122 South Second Street. It was home of the First Women's Bank from 1919 to 1926, became the Montgomery Hotel sometime prior to 1938, and was razed in 1971. There is a man sitting on the second-floor balcony just to the right of center. The hotel was known for its cool porches, wonderful food, and attractive ladies.

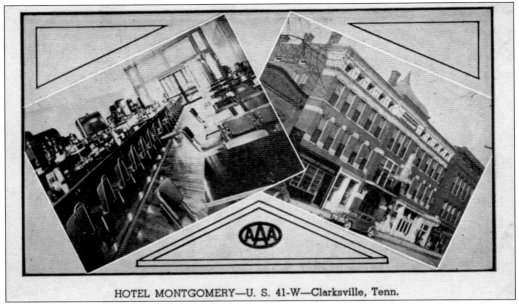

HOTEL MONTGOMERY—U. S. 41-W—Clarksville, Tenn.

This card of Hotel Montgomery advertises rooms on the "European plan—$1.50 and up." Mrs. Opal Edmondson was the long-time owner and operator of the hotel. Secretary of State Cordell Hull and Guy Lombardo were guests at the hotel. Ursula Beach once observed, "There were elegant parties there."

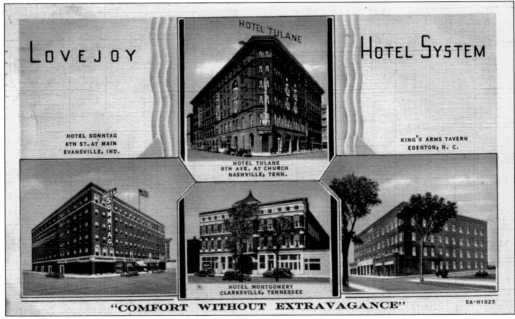

The Lovejoy Hotel System included Hotel Sonntag in Evansville, Indiana (left); Hotel Tulane in Nashville, Tennessee (center top); King's Arms Tavern in Edenton, North Carolina (right); and Hotel Montgomery in Clarksville (center bottom). Hotel Montgomery was the Arlington Hotel when H.J. Grimes sold it to Lovejoy in 1938.

On January 16, 1947, Mayor Kleeman disclosed plans for a new 80-room hotel to be owned by Pepperdine University. It displaced A.T. Winn Service Station and the Gulf Service Station. During the 1950s, young ladies would lean out of the windows of the hotel on military paydays and wave their undergarments at soldiers driving around the block. Royal York was selected as the hotel name from entries in a newspaper contest.

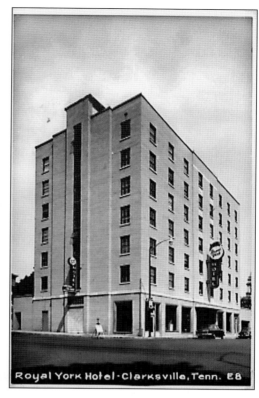

Royal York Hotel·Clarksville,Tenn. E8

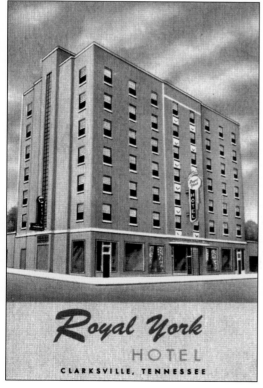

Royal York
HOTEL
CLARKSVILLE, TENNESSEE

Gen. Omar Bradley was a frequent guest at the hotel during visits to Fort Campbell. In 1986, Anna and Cecil Radford bought Royal York Hotel, which is located at the corner of Madison and Third Streets. At that time, there was no air conditioning and Frank Hart, who still resides there, ran the manually operated elevator. Today, the hotel is a 45-unit apartment building and has undergone a number of improvements by the Radfords.

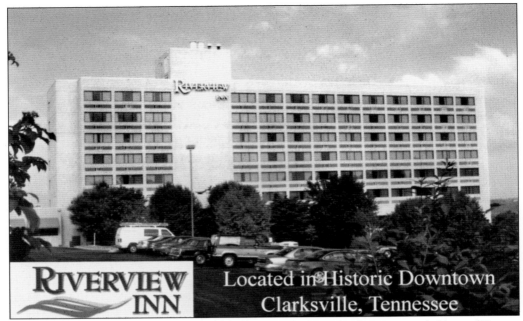

Riverview Inn is owned and operated by sisters Charlsie Hand Owens and Aimee Watson. McKenzie's Lounge on the first floor of the hotel is a favorite gathering place for those enjoying the nightlife. The inn hosts the Miss Tennessee and Miss Teen Tennessee pageants each year. It also hosts an annual Harley Riders convention.

The Best Western Motel was located at Exit 4 on Interstate 24. The back of the card says, "Faye and I stayed here the night we went to the Class Reunion. June 26, 1982." Today, this is the Country Inn & Suites, and the Best Western is now located two blocks away.

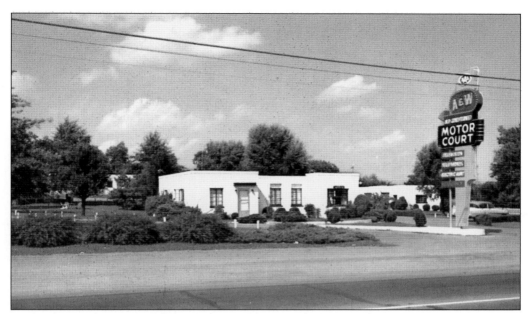

A&W Motor Court, a Madison Street mainstay since the late 1940s, was originally owned and operated by Mr. and Mrs. C.R. Bourne. The court proudly advertised 100 percent air conditioning, Beauty Rest mattresses, tiled bathrooms, electric heat, free television, and a telephone in every room.

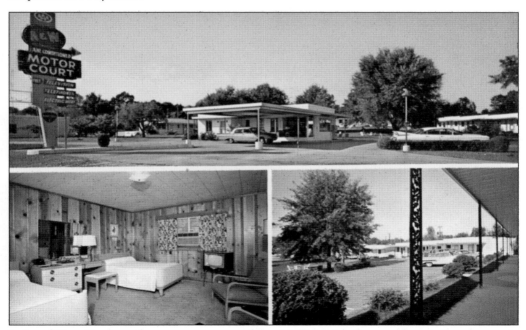

Jack and Tara Patel are the current owners of the A&W Motel; they purchased the property in 1996. Some rooms have been preserved with original décor. Local motel owners sold many of the tourist courts to Asian-Indian businessman Sitaram Patel when they learned Interstate 24 would by-pass the Clarksville business district.

Maple Inn was located at 1509 Madison and was outside the city limits in 1947. At that time, it was owned and operated by Dorothy and Al Winston. J.H. and Dorothy B. Edmondson are listed as owners and operators in the 1954 city directory. It is now the site of Perry Auto Service Station and next door to Ms. Annie Doris Pedigo's Antique Shop.

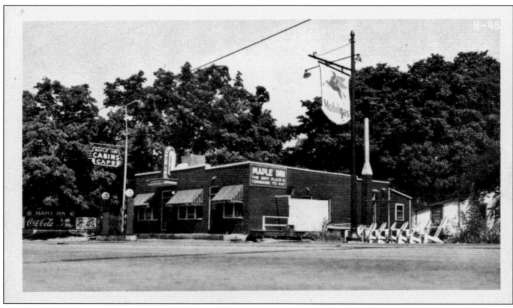

In about 1960, Walter Garnett Ladd bought the Maple Inn property and bulldozed it. The inn had a restaurant and lounge downstairs. Today, the basement, which survived the bulldozing, and remnants remain. The Bicycle Shop and Jiffy Burger are directly across the street from where the inn stood.

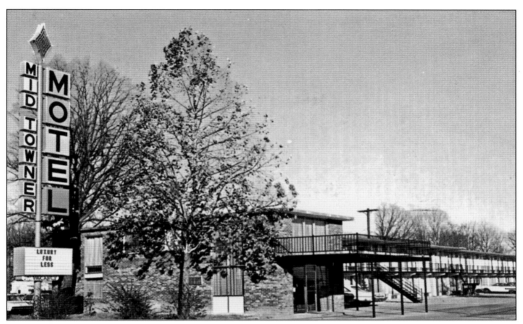

Mid Towner Motel, now Midtown Motel, is located at 890 Kraft Street. Readers may recall a motel maid contacting *Unsolved Mysteries* when they showcased a bank robber she recognized as a motel guest. He was arrested without incident and had two suitcases full of money in his possession.

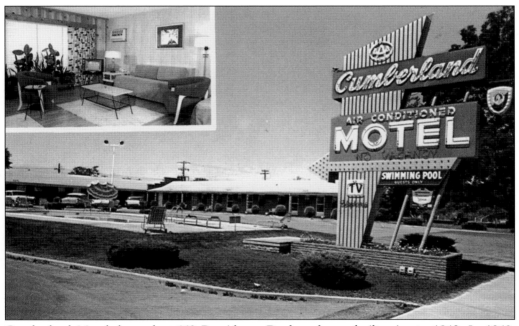

Cumberland Motel, located at 660 Providence Boulevard, was built prior to 1942. In 1960, Margaret and Dick Cobb were the owners/operators.

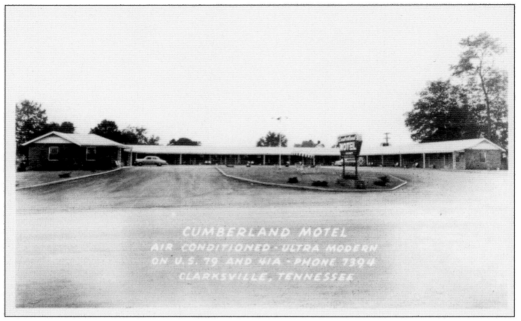

Today, Cumberland Motel is commercially idle. There are "For Sale by Owner" signs posted about the property. The only activity is an occasional yard sale in the parking lot.

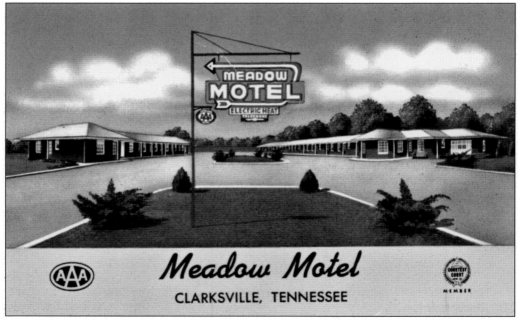

Ed and Ann Jurka's Meadow Motel on Highway 41A South was a mile outside the city limits when this card was printed around 1952. Rasik Shah owned it from 1984 to 1994. The motel looks much the same as in this drawing; however, current owner Kaushik Patel is remodeling.

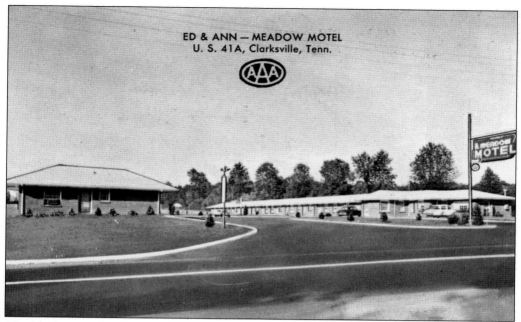

This black-and-white card of Ed and Ann's Meadow Motel was printed in the 1950s when AAA ratings separated fine motels from the rest. Still located at 1991 Madison Street, it is now simply the Meadow Motel.

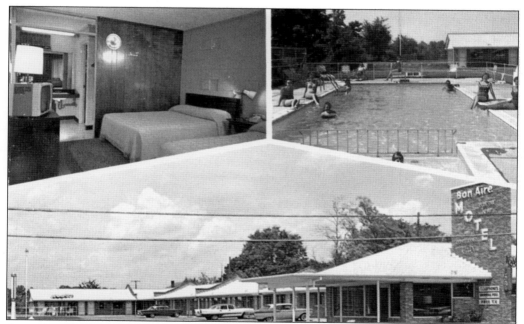

Sonny Patel has owned Bon Aire since 1984. Today, Sonny is remodeling the 24 rooms; however, the swimming pool is gone. The motel is thought to be 35 years old. In 2003, Psicosis, the professional wrestler from Tijuana, Mexico, was a guest here.

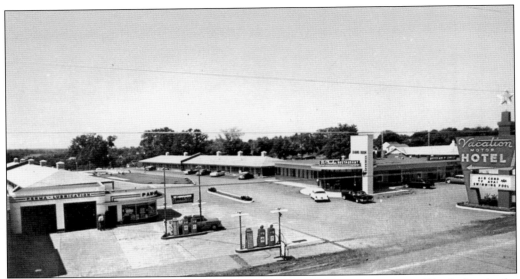

This motel is located at 650 Providence Boulevard. The Vacation Motor Hotel sign is the trademark Holiday Inn sign. Holiday Inn founder Kemmons Wilson was a friend of the owner and encouraged him to use the sign. Once a beautiful and proud establishment, it is now in a neglected part of town.

There are many postcards of motels and cafes between Clarksville and Nashville. Some cards describe these businesses as being on Highway 41A, while others refer to this road as the Clarksville Highway.

Nine

FORT CAMPBELL AND SURROUNDING COMMUNITIES

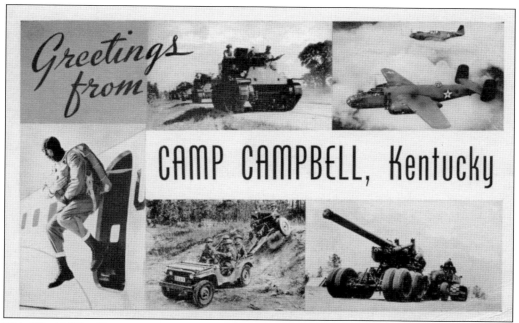

This World War II–era greeting card shows multiple views of Camp Campbell. Elmira writes to folks back home in New Ulm, Minnesota, "He didn't come in again last night, so I will go to the Camp Airfield again tomorrow." Free franking privileges, as on this card, have always been afforded military members during wartime, and there are many interesting examples of those philatelic ephemera.

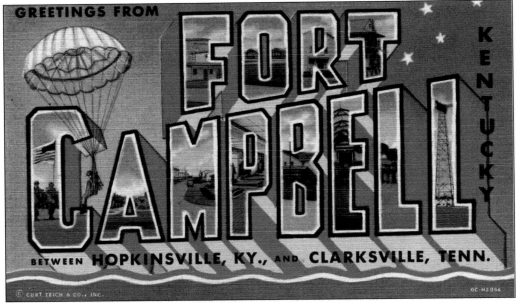

This large-letter postcard illustrates the sense of ownership both Clarksville and Hopkinsville, Kentucky, have regarding Fort Campbell. Originally designated Camp Campbell, Tennessee (most of the installation is in Tennessee), the change to Kentucky occurred when the post office was constructed on the Kentucky side of camp. Many Fort Campbell commanding generals have made impressive contributions in the annals of military history.

The U.S. Air Force has always played a prominent role in the operation of Campbell Army Airfield. This Air Force C-124 Globemaster is positioned on a keyhole at the airfield. In 1985, 248 Fort Campbell soldiers and 8 crewmen were killed when an Arrow Air charter bound for Campbell Army Airfield crashed after takeoff from Gander, Newfoundland. President and Nancy Reagan, along with many from Clarksville and Hoptown, attended the Fort Campbell memorial services.

In 1956, the 101st Airborne Division was reorganized with pentatomic concepts to become the first nuclear capable airborne division in the world. Earlier, the secretive Clarksville base (often referred to as the Birdcage) played a role in projects related to atomic weapons. The author served as Fort Campbell's radiation protection officer and accident investigator for approximately 15 years.

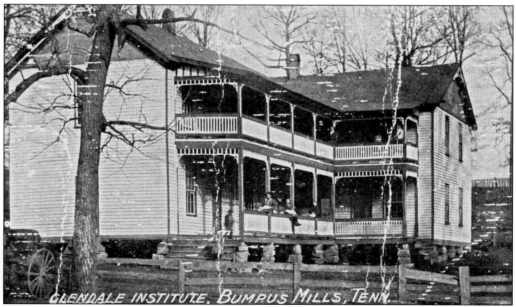

Research has revealed little about this 1911 postcard of Glendale Institute, Bumpus Mills. It was a boarding school funded partially by the county with remaining tuition paid by subscription. Miss Mary Florence Betts, known by many in Clarksville, was a teacher there. The school was well respected in the late 1800s and early 1900s.

THE BLANKET STORE
Pleasant View, Tennessee

Clarksvillians routinely stopped at Pleasant View's Blanket Store on the way to Nashville. The store's specialties were blankets and chenille bedspreads. Built by Clifton and Pearl Pearson, they purchased irregular blankets from Springfield Woolen Mills for resale. To attract customers they had a man lying in a pit with rattlesnakes and kept a caged bear. Ernest Hemingway's mother often stopped there.

the Battle of Riggins Hill at
Historic Collinsville

Historic Collinsville is an authentic old village that has been featured in *Southern Living* magazine and on television's *Tennessee Crossroads*. Operational cost and lack of public support continues to concern those interested in the village's survival.

Located across the border near Guthrie, this building was once the Graysville Inn. Visitors are said to have included Jenny Lind, Andrew Jackson, Jesse James, Gov. Frank Clements, Vice President Alben Barkley, and many other recognizable personalities.

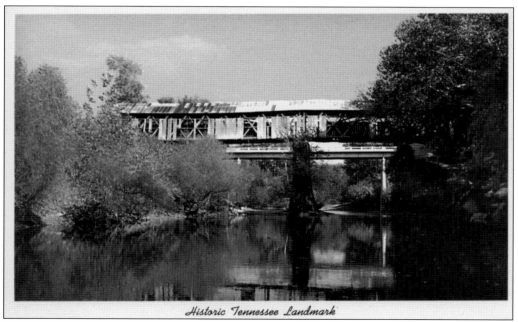

Historic Tennessee Landmark

The community of Port Royal was settled in 1783. The Trail of Tears, a forced march of the Cherokee Indians, crossed the Red River near the site of this bridge. Port Royal Bridge, destroyed several times, was not rebuilt after floodwaters demolished it on June 12, 1998. Several accounts have been established to collect funds for rebuilding, and a petition has circulated, but efforts to have it replaced have been unsuccessful.

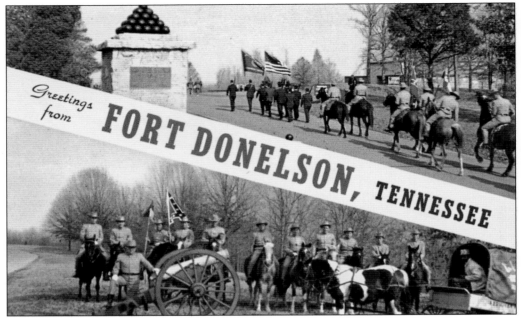

The 49th Tennessee Infantry served and surrendered here, as did other Confederate units. Once Fort Donelson fell, it was easy for the Union to advance to Clarksville, Nashville, and deeper into the South. The famed Blue Raider (Nathan Bedford Forrest) refused to surrender and went on to fight brilliantly throughout the war. The Red River Raiders skirmish unit from Clarksville is shown on this card.

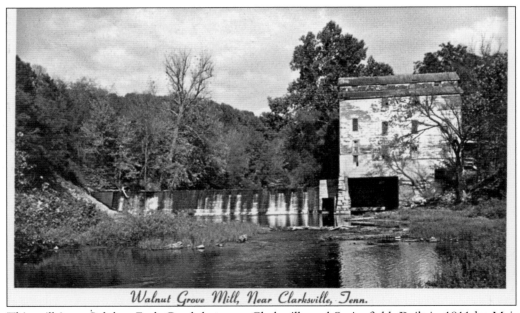

Walnut Grove Mill, Near Clarksville, Tenn.

This mill is on Sulphur Fork Creek between Clarksville and Springfield. Built in 1811 by Maj. James Norfleet, it has been known as Norfleet's Mill, Moody's Mill, Hill's Mill, Beech Valley Mill, and Walnut Grove Mill. When it closed in 1963, it ended 152 years of service.

This is a first edition postal card from June 1, 1961; it is thought to be a celebration of the first airmail flight from Outlaw Field. The airport in the northern part of the city is named for the "Father of Clarksville Aviation," John Outlaw.

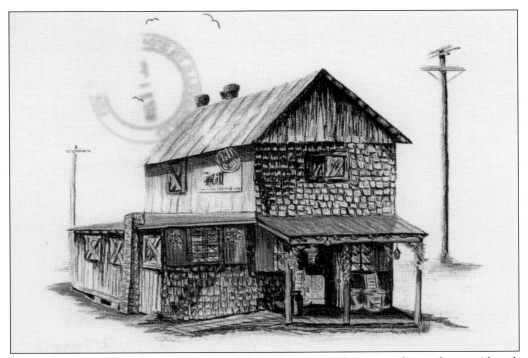

Susan Ross owns the mill on Dover Road. It has been moved twice as the road was widened; in the late 1930s, it was moved from what is now the middle of Highway 79. Susan's son Mike Ross is an artist. He did a number of political cartoons for *The Leaf-Chronicle* and designed several local postcards.

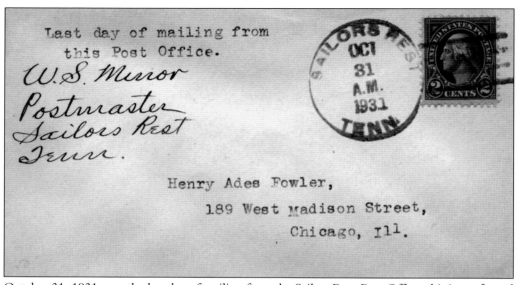

October 31, 1931, was the last day of mailing from the Sailors Rest Post Office; this is confirmed by postmaster W.S. Minor's signature. The small community of Sailors Rest is just beyond Yellow Creek along Highway 149.

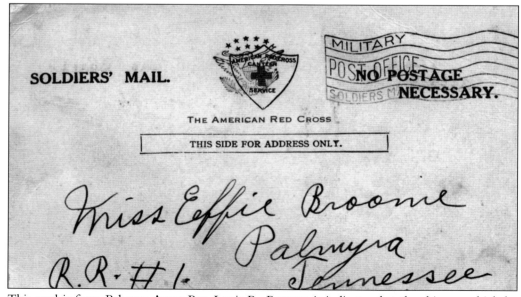

This card is from Palmyra Army Pvt. Louis R. Powers; it indicates that the ship on which he sailed had arrived safely overseas. Devada Elliot, who was married to Vernon Presley, is also from the Palmyra area.

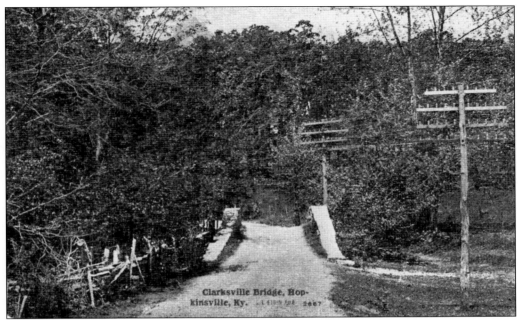

This photograph features the Clarksville Pike between Hopkinsville and Clarksville. The road and bridge were widened after a fiery crash took the lives of four Fort Campbell nurses in 1956.

Kentucky Lake is just south of Land Between the Lakes. It is here that Elvis visited with Carl Moseley. Jim and Lynn Butkowitz have a home on the lake, as do many Clarksvillians. Some live there year-round and others just during summer months. Lisa Ray can often be found skiing on the lake.

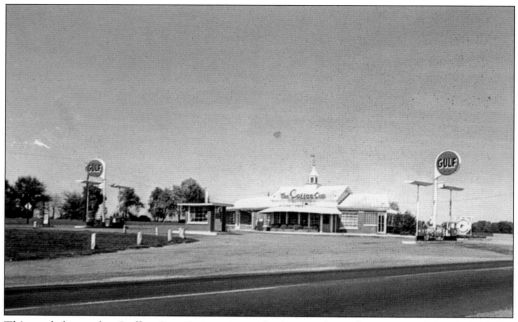

This card shows the Coffee Cup Restaurant at the intersection of U.S. 41 and 79. It provided 24-hour service in the Tiny Town and Guthrie areas.

In many ways a community all its own, the Cumberland River winds through the heart of Tennessee. From Clarksville, she is navigable downstream to the Ohio River and more than 350 miles upstream. A portion of the Red River is also navigable.

Ten

NOVELTY AND MISCELLANEOUS VIEWS

These colorful and attractive lithographs are trade cards and were often circulated with household products. Those not familiar with lithographs often mistake them for postcards. Some collectors feel, "If it looks like a postcard, and feels like a postcard, it's a postcard."

On July 4, 1986, the Suiter and Manning families held a reunion at the Clarksville fairgrounds. This card was from Mrs. Frances Clinard of Knoxville to Mr. and Mrs. Rex Stephenson of Trenton, Kentucky.

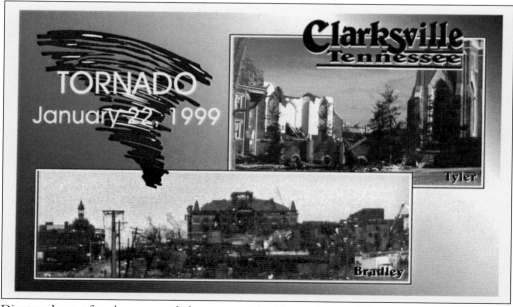

Disasters have often been recorded on postcards. The author and Action Laser Products Inc. owner, Beverly Maki, collaborated on this card immediately after the tornado of January 22, 1999. The back of the card is autographed by Stacy Allison for Tyler Butts. Stacy was the first American woman to climb Mount Everest. Tyler was a freshman at APSU.

The author purchased this card while visiting friends on the island of Sardinia. It is interesting that the Italians thought Clarksville was west of the Tennessee River in the northwest corner of the state.

GREETINGS FROM CLARKSVILLE, TENN. C-1168

When de golden moon
comes creepin' up
Across de fah horizon,

Dah's a suttin sweet
honey chile
Ah's espeshul got mah
eyes on.

DEAR				WILL BE
Friend				Seeing you
Old Kid				Gone longer
Sweetie				Thinking of you
Folks				Writing you again
Old thing				Going to bed
Husband				Stepping out
Wife				I HAVE SEEN
Boys \| Girls				Friends
HOW ARE YOU?				Races
I AM				Shows
Flying high				Parks
Feeling great				Night clubs
Missing you				Fights
Broke				Baseball games
Well				Lots of good-looking girls
Happy				Lots of good-looking men
WISH I HAD				Lots of fish
You	DOING LOTS OF	Golfing	Been true to me	YOURS
More sleep	Sight-Seeing	Everything	Not forgotten	Till the cows come home
More money	Thinking of you	Traveling	how to write	With love
More time	Work			Sincerely
Some one to love me	Loafing	HOPE YOU HAVE	THINGS ARE	Forever
Some kisses	Sleeping	Not forgotten me	Fine	NAME *Mary*
More ambition	Night clubs	Behaved yourself	Tough	
A post card	Petting	Been having fun	Slow	
	Shows	Kept well	Exciting	

Busy Person's Correspondence Card — Time is Money — Check Items Desired © C. T. & CO.

This *c.* 1939 card was intended for people who did not have time to write. Postcards often depict people in humorous or unflattering ways. African-American postcards have been studied to learn about black dialects.

This attractive generic postcard was postmarked Clarksville, 1907. The message, from K.C. to Mr. Catlott Hambough at RR # 4, Clarksville, includes, "Do you understand Dog Latin? I hope so fors (sic) if you do we can exchange postals written in it." Many correspondents developed their own code for use on postcards.

Curt Teich and Company printed this card. It was mailed from a soldier who resided at 624 College Street in September 1944. He states, "The hours are long. Hurry and write me, I'm dying for some mail." There are hundreds of generic cards of Clarksville.

This is a rare Clarksville divided back postcard with a patriotic theme. Patriotic cards became popular in the early 1900s; they enjoyed that popularity through World War II, when they disappeared for the most part—until September 11, 2001. From an artistic perspective, modern cards are not as attractive as the cards before 1940. This card was printed in Germany and is postmarked 1909.

This card, dated January 15, 1908, shows eight Clarksville scenes, which also appear on individual cards the author has collected. This is an undivided back card. If you wanted to include a message, you had to find room for it on the front as this person did. The message at the bottom states, "Snow on ground first of season."

My View of

CLARKSVILLE, TENN.

Where there is always a belle to ring!

Golda Riggins mailed this card, postmarked at the Clarksville Post Office in 1927, to Mr. Grady Privitte, Route 5, Clarksville. The price of postage for postcards was increased to 2¢ for the period 1917 to 1919. That action was rescinded in 1919 only to return to 2¢ in 1925. Today, the cost to mail a postcard in the United States is 23¢.

```
M - is for the million things she gave me
O - is only that she's growing old
T - is for the tears she shed to save me
H - is for the heart of purest gold
E - is for her eyes with love light gleaming
R - is for the Right, and right she'll always be

Put them all together, they spell "MOTHER"
A word that means the world to me!

Honor MOTHER by attending Margaret Owen
Circle, meeting with Mrs. John Happer,
Greenwood Ext., Monday evening 7:30
```

This is a beautiful 1941 postal card with an embossed cameo of a mother. It asks the addressee to "Honor Mother" by attending a Margaret Owen Circle Meeting with Mrs. John Harper, Greenwood Ext.

Carlton Bousman, owner of Gate 3 Printers, and his brother Walker designed this QSL card in the early 1960s. "QSL" is the radiotelegraph code meaning "I confirm." It is not an abbreviation or acronym. A QSL card from a radio operator notifies another that their transmission has been received.

While this leather card was purchased from a printer, they were often handmade using burning kits. Many times these cards were made with scalloped borders or with commercially punched holes around the edges for a piece of rawhide. They were often tied together to create a pillow look. Occasionally, as with this one, some color was applied. There are relatively few leather Clarksville cards.

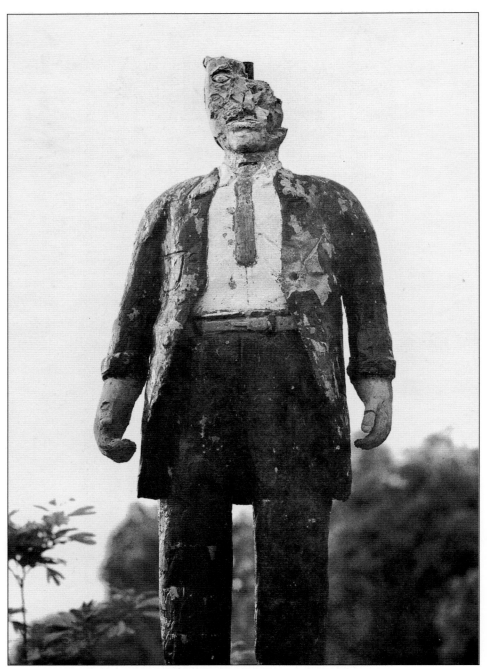

Enoch Tanner Wickham (1887–1970), a local self-taught artist, created approximately 40 outdoor monuments in Palmyra. The statues were of Daniel Boone, Patrick Henry, John F. Kennedy, Sgt. Alvin C. York, Austin Peay, and Wickham himself. Many of his works have been vandalized. The Customs House Museum Guild used this card as invitations to a reception and showing of the sculpted works. The card is 6 inches by 8.5 inches and used non–profit United States Postage Permit No. 530.

The Clarksville Montgomery County Tourist Commission printed this rectangular card. The multiple views are of Dunbar Cave Bathhouse, Land Between the Lakes (known locally as LBL), Fort Campbell soldiers, and Clarksville Public Square. Cards similar in size and shape were widely used in the 1940s and 1950s. They were not well received, were seldom mailed, were of little interest to collectors, and had a poor survival rate.

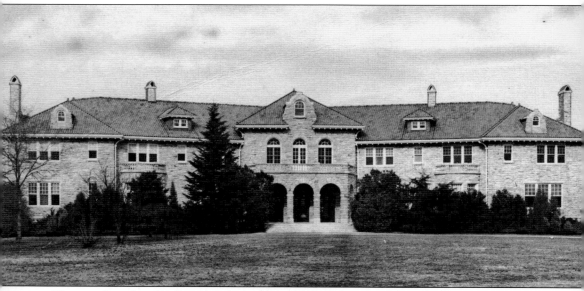

Clarence Saunders (1881–1953) had a limited education. He was a salesman for Hurst-Boilin Wholesale Grocers in Clarksville when he founded Piggly-Wiggly grocery stores in 1916. This pink Georgia marble mansion he built in Memphis was unfinished when he lost his Piggly-Wiggly fortune. These cards are referred to as Jumbo or Giant Cards and measure seven inches by nine inches or larger.

Clarksville Liquor Company was owned by Herman Marx and offered mail-order liquor. Blackberry Wine was $1.25 a gallon; Penwick Rye, which all doctors recommended for sickness, was their most expensive at $3 a gallon; and Tennessee White Corn Liquor, the whiskey that made the rabbit spit in the bulldog's face, was $2 a gallon. The company also sold fine cigars. They also guaranteed their goods to be directly from U.S.-Bonded warehouses and distilleries and, as a result, medicinally pure.

SEASONS GREETINGS

YOUR NEWSPAPER CARRIER

Kay Dixon

THE LEAF-CHRONICLE

Clarksville's newspaper dates to 1808; a merger in 1890 with the *Tobacco Leaf* created *The Leaf-Chronicle*. In the 1990s, *The Leaf-Chronicle* paper carriers left season's greeting cards in the paper boxes of subscribers. In 1993, Kay Dixon at 32 Dalewood Drive was the carrier on Highway 12. The back of the cards included a calendar for the new year.

Colton State Bldg — Mr. West

USES 508.1 (10-43) EMPLOYER'S COPY OF REFERRAL CARD

To *Tennessee Eastman Corp.*

ADDRESS *517 Union Ave*

APPLICANT *Josephine S. Teeple* Soc. Sec. N *408-26-5922*

FOR POSITION OF *TRAINEE*

DATE TO REPORT *3-3-45* A. M. _____ P. M. _____

This applicant is referred in response to your request. Referral by the United States Employment Service certifies that the hiring of this worker for the employment specified above is in accordance with the War Manpower Comm'.sion Employment Stabilization Program, and no accompanying statement of availability is required.

If the applicant is hired, this form should be retained in your files and be available for inspection.

If the applicant is not hired, this form should be discarded.

Prompt return of the accompanying referral card, with necessary entries, will be appreciated.

UNITED STATES EMPLOYMENT SERVICE

Nellie A. Cook

16—35431-1 *Representative.*

This postal card was used for U.S. Employment Service referral. On this card, Josephine S. Teeple of Clarksville is applying for employment with Tennessee Eastman Corporation. The card is dated March 3, 1945, and includes her social security number (a harmless practice then, but one that could result in identity theft today). Josephine died in a motorcycle accident on July 9, 1946.